IMAGES
of America

MATTESON

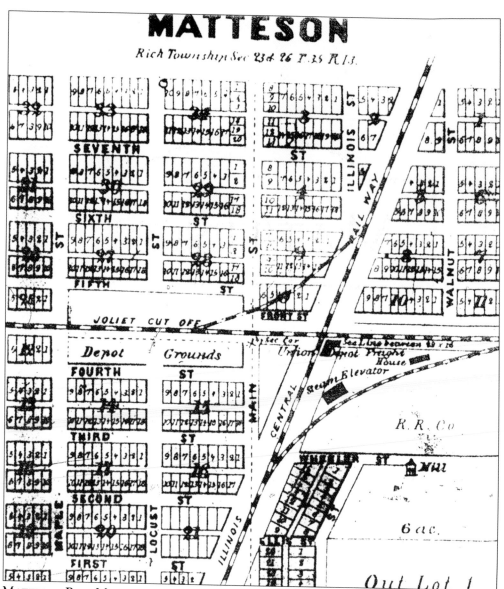

MATTESON PLAT MAP, 1886. This is one of the earliest maps of the village. It shows the village as a small community located at the busy crossing of the Illinois Central and Michigan Central Railroads. Agriculture was an important part of the economy with a steam grain elevator located at the southeast junction of the two railroads. Figures show the population was 500 in 1880 with little growth until 1940 when the population was 800. Subsequent figures show the number at 1,200 in 1950, 3,200 in 1960, 4,700 in 1970, and 10,200 in 1980.

On the cover: **LINCOLN-OLYMPIA WAY GARAGE.** One of the first business establishments in Matteson along the Lincoln Highway was this auto service garage, later to be called Meyer's Garage. Oscar Dettmering is standing second from left. Walter Ziebell is second from the right, and Sam Reese is on the far right. The garage was demolished when the highway was widened in the early 1980s. Matteson Fire Department station No. 1 currently stands on the site. (Courtesy of the Matteson Historical Society.)

IMAGES
of America

MATTESON

Paul W. Jaenicke

ARCADIA
PUBLISHING

Published by Arcadia Publishing
Charleston SC, Chicago IL, Portsmouth NH, San Francisco CA

Printed in the United States of America

Library of Congress Catalog Card Number: 2006926499

For all general information contact Arcadia Publishing at:
Telephone 843-853-2070
Fax 843-853-0044
E-mail sales@arcadiapublishing.com
For customer service and orders:
Toll-Free 1-888-313-2665

Visit us on the Internet at http://www.arcadiapublishing.com

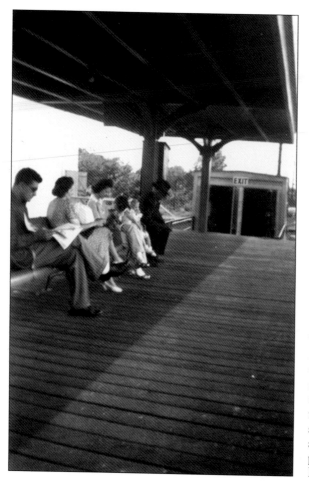

WAITING FOR THE TRAIN.
This scene has been a part of
Matteson's history since 1853.
Commuters living in the village
and surrounding areas have been
using trains to commute to Chicago
for work, entertainment, shopping,
school, and many other activities,
as can be seen in this mid-1950s
photograph taken at the Matteson
Illinois Central platform.

CONTENTS

ACKNOWLEDGMENTS

Many people have made this book possible through the giving of photographs and information to the Matteson Historical Society. The Matteson Historical Society has a lot of documented material about the history of Matteson that will be of help to future generations of historians and residents alike who are interested in the history of this community. There are many people to thank for the stories and photographs they shared with me. Specifically I would like to thank Ed Auman, Lois Blume, Beverly Denman, Ralph Eisenbrandt, Wilbur Ellis, Charles Grosche, Kay Grosche, Otto Juergens, Carmen Kimble, Alan R. Lind, Tim Mahler, Paul R. Meyer, Wil Niemeyer, Dr. William Pakosz, Bill Praye, Edie Umland, Elaine Umland, and Jim Wright for the help they gave me in writing this book. Special thanks go to June and Joe Staackmann of the Matteson Historical Society for the cooperation they gave me in letting me use the historical society's pictures and archives. Finally I would like to thank the following organizations that were helpful in making this publication possible: Illinois State Historical Library, St. John's Faith United Church of Christ, St. Lawrence O'Toole, United States Post Office–Matteson, Illinois, and Zion Evangelical Lutheran Church.

INTRODUCTION

The area we know as Matteson was originally occupied by Potawatomi Indians. After the conclusion of the Blackhawk War in 1832, when various American Indian tribes moved west of the Mississippi River, European settlers came from eastern states to settle in the area. Many of these settlers had followed the Sauk Trail, a rough pathway that passed to the south of the area and was used by tribes traveling between Detroit and Rock Island, Illinois.

In 1848, Frederick Illgen bought the first 40 acres of public land in what would become the southern section of Matteson for $50. German immigrants with last names of Mahler, Stuenkel, and Weishaar, to name a few, were the first to seek farming and business opportunities in the community during the 1850s. In June 1855, the area was surveyed for Nelson Elwood and Jacob Rich. It was named after the 10th governor of Illinois, who held office from 1853 to 1857. The coming of the Illinois Central Railroad in July 1853 and the Joliet and Northern Indiana Railroad, later to be called Michigan Central in May 1855, were the reasons for the surveying. The Michigan Central was completed between Joliet and East Gary, Indiana, in 1855, and the Illinois Central was completed between Chicago and Cairo, Illinois, in 1856. Charles Ohlendorf was the first homeowner in town and also became the first merchant and postmaster.

The first public school was established in 1860. By 1868, the German Lutheran School, later to be called Zion Lutheran School, was founded. Zion also started the first church in the community in 1878. Matteson had a population of 500 by 1880 and had a thriving business community consisting of two hotels, two general stores, two saloons, and two harness shops, as well as a blacksmith, wagon, and implement shop. The town was incorporated in 1889, and the volunteer fire department was organized in 1894. By 1888, the Elgin, Joliet and Eastern Railroad was built through town, becoming Matteson's third railroad. This line formed a beltway around Chicago reaching to Waukegan in the north and to Porter in the east. In 1897, a new village hall along with a new fire station was dedicated.

Between 1890 and 1913, Elliott's Park, built at the corner of Route 30 and Kedzie Avenue, was catering to upwards of 30,000 people coming from Chicago on weekends on special Illinois Central trains. The entertainment included a dance hall, merry-go-round, and bowling alley.

Transportation developments served the community well when residents were able to ride an interurban streetcar between Chicago Heights and Joliet between the years of 1908 and 1922. Another major milestone in the development of the community was the start of Illinois Central commuter service to Chicago in 1912 and the electrification of the line in 1926. In anticipating this development, the railroad had elevated its tracks through town in 1922 using dirt brought from Monee to the south. The Egyptian Trail was a Chicago-to-Cairo road that

came through Matteson in 1916. By 1930, state Route 49 (Governors Highway), later to be called U.S. Route 54, had replaced it with a paved route to Kankakee, Illinois. The Lincoln Highway was conceived as the first transcontinental highway in 1913, passing through the northern part of the village. Matteson Public School was expanded with a new addition and brick face-lift in 1916. A two-year high school program was started in 1928 and ran until 1942. The American Legion Rehfeldt-Meyer Post 474 was founded in 1931, and the first Boy Scout troop was sponsored by the Parent-Teacher Association in 1936.

Following World War II, growth was inevitable and Matteson became a choice residence for returning soldiers. A new village hall along with facilities for the police and fire departments was dedicated at the corner of 215th and Locust Streets in 1948. This facility had replaced the old village hall and was a reflection of the post–World War II growth happening in the community. Memorial Park was dedicated the next year with the names of 177 servicemen who had served in World War II inscribed on a plaque that was supported by stone taken from the foundation of the old village hall.

In 1955, the village celebrated its centennial with a weeklong celebration that included pageants and a parade. Population increased dramatically from about 1,200 residents in 1950 to over 3,200 in 1960. As a result of these new developments, new schools were built at Sieden Prairie in 1962 and Matteson Elementary in 1964. The original school building became the Huth Upper Grade Center. A major stimulus to growth on the western part of town was the completion of Interstate 57 in 1968. This started a phenomenal retail growth in the 1970s with the building of Lincoln Mall in 1973. Other strip mall sites were subsequently developed, making Matteson into a major retail shopping area for the south suburbs. Today Matteson has over 15,000 residents. The city continues to grow in the western boundaries of the community in the form of retail and residential development.

Designated historic sites in Matteson are as follows: Hahne Family Home (3616 West 216th Street), Gross House (3624 West 216th Street), Village Barber Shop (3612 West 216th Street), German American Bank (3610 West 216th Street), Maloni's Tavern (3601 West 216th Street), Dettmering's Old Fashioned Tavern (3613 West 216th Street), Mahler's Service Station (3627 West 216th Street), Nortmeier House (3735 West 216th Street), Zion Evangelical Lutheran Church (216th Place and Maple Street), Matteson Public School site (213th Place and Locust Street), St. Paul's Evangelical Lutheran Church (6200 Vollmer Road), Sieden Prairie School (6220 Vollmer Road), Matteson Village Hall site (215th Street and Locust Street), and Herman Stege House (3720 West 216th Place).

One

EARLY DAYS

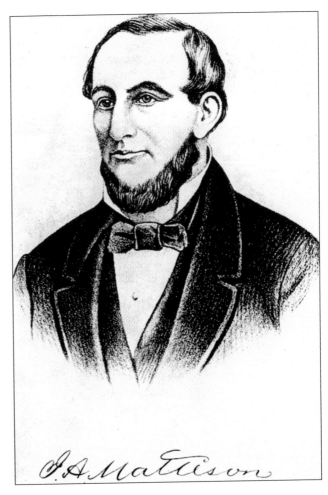

JOEL MATTESON. The village was named after the 10th governor of Illinois, who served between 1853 and 1857. He was born in Watertown, New York, in 1808. The son of a Yankee farmer, Matteson was a merchant, teacher, and railroad builder in South Carolina before he brought his wife and child to Illinois. In 1836, he came to Joliet and became a contractor on the Illinois and Michigan Canal and started a woolen mill. He was also a director and promoter of the Joliet and Northern Indiana Railroad, later known as the Michigan Central, which was built through the village in 1855.

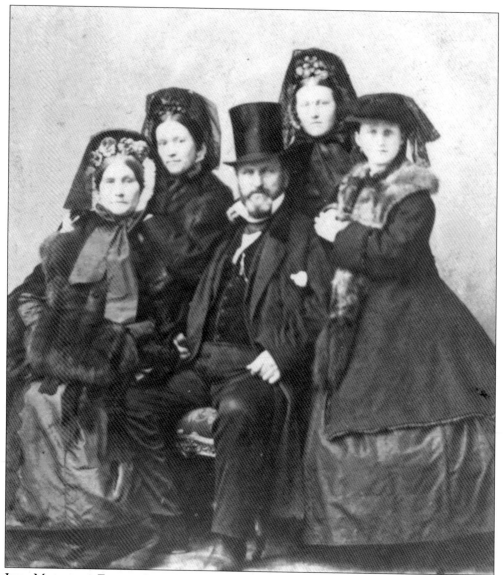

JOEL MATTESON FAMILY. In 1852, Joel Matteson, a Democrat, was elected governor. During his term he was instrumental in starting the state public school system, paying off a massive state debt, and building the governor's mansion in Springfield. In 1859, he was implicated in the fraudulent sale of the Illinois and Michigan Canal scrip, but no formal charges were ever brought against him. Later he agreed to repay most of the money in question plus interest. He died in January 1873 and is buried in Joliet. There is no evidence that he ever owned any land or officially visited his namesake town. This picture is presumed to have been taken at the time he was governor. From left to right are his wife Mary, Belle, Joel, Clara, and Mary Jane. There was one son in the family who was killed in Corinth, Mississippi, during the Civil War.

JAMES FREEMAN DANA ELLIOTT. Born in Franklin County, New York, in February 1824, James Elliott bought 400 acres in Matteson starting at Front Street and running all the way to 207th Street, in what is now Olympia Fields. A pig farm operated here during the Civil War. Hogs were shipped south on the Illinois Central to feed the Union armies during the Battle of Vicksburg. Elliott was a friend of Abraham Lincoln and also knew Sen. Stephen A. Douglas.

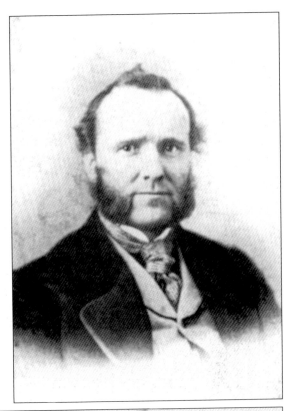

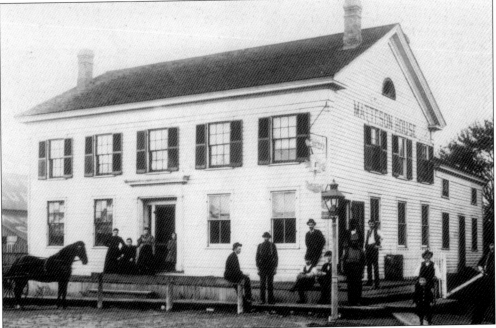

MATTESON HOUSE HOTEL. Opened in 1861 by L. D. Mills for train travelers, the Matteson House Hotel was considered to be a first-class hotel and restaurant establishment for its day. It sat at the northwest corner of the Illinois Central–Michigan Central crossing.

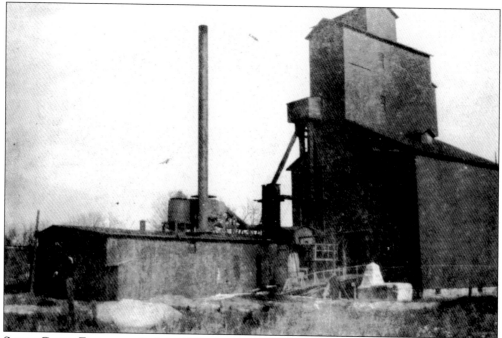

STEGE GRAIN ELEVATOR. Built in 1881, this elevator was reportedly moved nine years later from a location near the Elgin, Joliet and Eastern tracks to across the street from the village hall next to the Michigan Central tracks. This structure stood 180 feet tall. Moving the structure was considered to be a big event for its day.

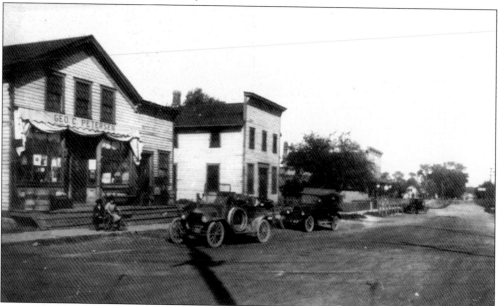

PETERSEN'S GENERAL MERCHANDISE STORE. This store stood at the northwest corner of Third and Main Streets. It served as an ice-cream parlor and delicatessen shop in the 1920s. It later became Bunky's and then Freeh's. To the right of this building was a saloon owned by Albert Reese. Farther down the street was Fortmiller's General Store, which also served as the post office until the mid-1950s.

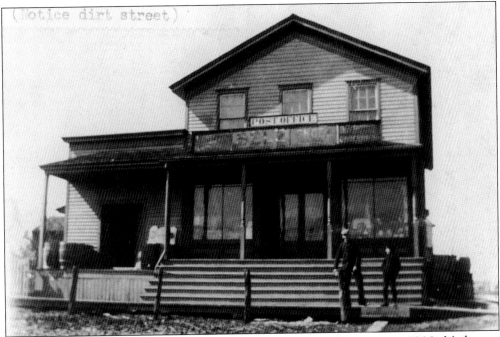

(Notice dirt street)

MATTESON POST OFFICE, CORNER OF FOURTH AND MAIN STREETS, C. 1900. Mail came on Illinois Central passenger trains twice a day and village residents were required to pick up their mail at the post office. Not until the mid-1950s was home delivery made available to the residents.

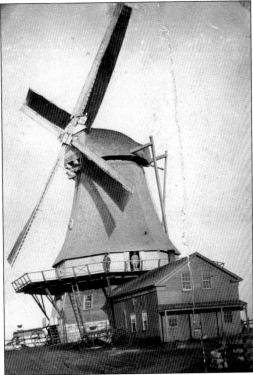

WINDMILL. Constructed in the early 1870s, this windmill stood on the southeast corner where the Michigan Central crossed the Illinois Central. This is the present location of the east Metra parking lot. Wind power was used to grind grain that was grown by local farmers.

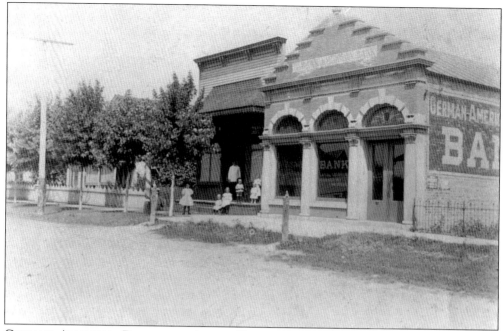

GERMAN AMERICAN BANK AND ADAMS BARBER SHOP. Rudolph Adams established his barbershop, seen on the left, in 1896. The shop was a family business for over 50 years. The German American Bank was established in 1904 and closed its doors in 1937. The name was changed to First State Bank in 1917. This location was on Third Street near Main Street.

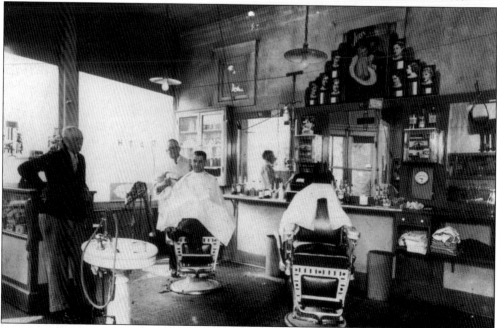

ADAMS BARBER SHOP, 1920S. This was the heyday of the Adams Barber Shop when services included a pool room, shaves, and baths at 35¢. This photograph was taken at a time when men did not shave at home but went to the barbershop instead. Rudolph Adams is shown serving one of his customers.

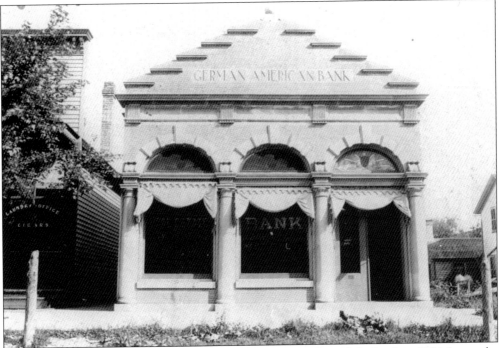

GERMAN AMERICAN BANK. Henry Stege was the first president of the bank in 1904. It was the only bank in Matteson and served both local residents and area farmers. One reported bank robbery occurred during the 1930s. The money was never recovered, and the bank robbers were never caught.

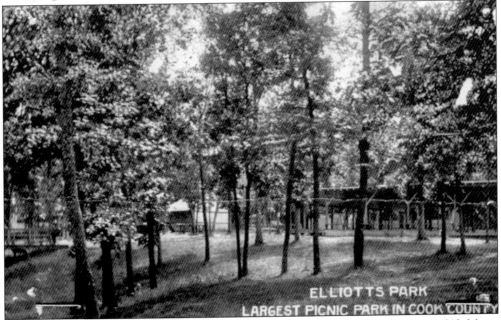

ELLIOTT'S PARK, CORNER OF KEDZIE AND THE LINCOLN HIGHWAY. From 1890 to 1913, Moses and Freeman Elliott operated an amusement park, which included a merry-go-round, dance pavilion, miniature golf course, and deer farm.

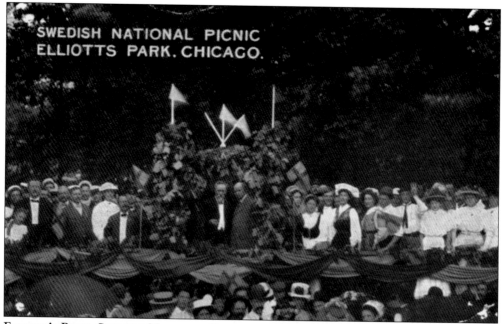

ELLIOTT'S PARK, SWEDISH NATIONAL PICNIC, C. 1900. Crowds of up to 30,000 people rode special Illinois Central trains from Chicago on the weekends. Wagons took people into the Matteson business district to patronize merchants. The grounds were later sold to developers to make way for a cemetery, which never became fully utilized.

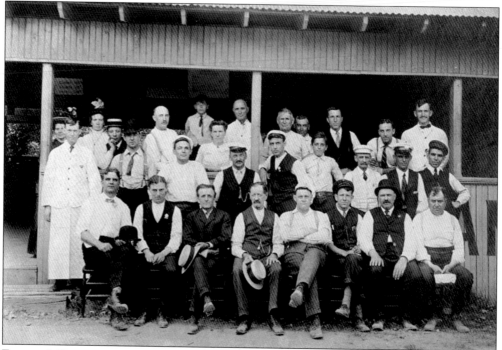

ELLIOTT'S PARK, C. 1913. Employees of the park pose for a group photograph with Moses Elliott, shown third from the left in the bottom row. The park was a major source of employment for the local residents in Matteson at the time.

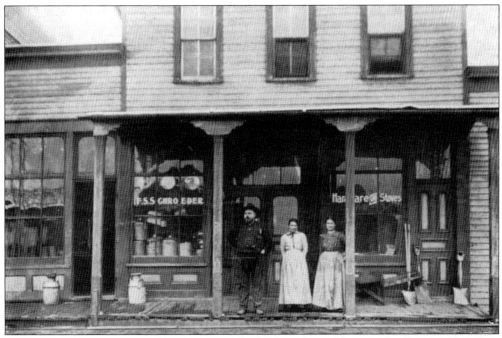

SCHROEDER'S HARDWARE STORE, C. 1900. Fred Schroeder and his two daughters are standing in front of the store. He was also in the blacksmith and meat market business at one time. This building is currently occupied by Stege TV at 3605 West 216th Street.

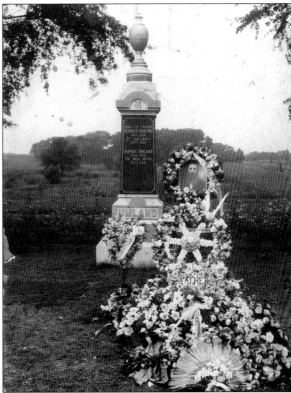

HEINRICH UMLAND, 1915. One of the early graves at the Zion Evangelical Lutheran Cemetery is for Heinrich Umland. This scene is looking west and to the right in the background is a rare view of the Lincoln Highway before it was paved a few years later.

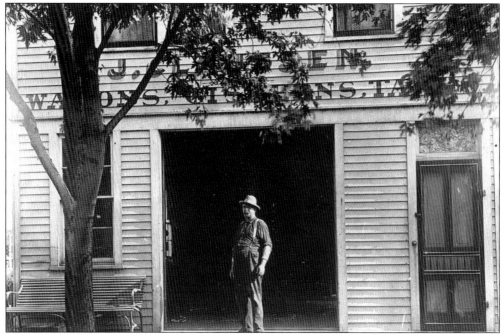

JOHN CLAUSSEN'S WAGON SHOP, C. 1900. In addition to repairing wagons, John Claussen was also in the lumber and coal business. Matteson had a small but efficient business district that catered to the needs of the residents before roads and the development of the automobile made it possible to travel to nearby towns to shop.

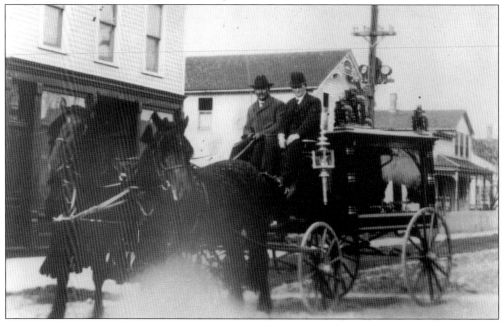

J. P. WEHREN, MATTESON UNDERTAKER, C. 1900. Besides being an undertaker, J. P. Wehren was also in the furniture-making business. When a call was received for a coffin, the body of the deceased would be prepared in the home and the coffin would then be brought to the residence. His business was located on the northeast corner of 216th and Locust Streets.

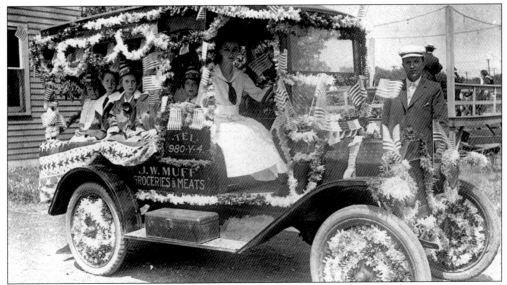

J. W. Muff Groceries and Meat, c. 1920. John Muff is seen standing on the right next to his decorated vehicle at a Fourth of July parade. The woman sitting in the front seat is Miss Mcquire, who was a schoolteacher. The girls sitting in the back row are, from left to right, unidentified, Lucille Muff, Alta Fortmiller, and Agnes Grosche. John Muff had run a slaughterhouse business for many years and owned a farm where the cattle were raised on what is now 207th Street. The slaughterhouse was built in 1914 and was located just behind his residence at 3616 West 216th Street.

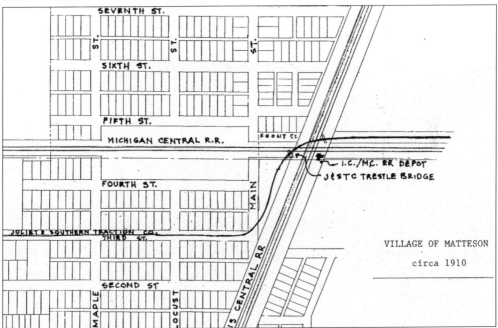

Interurban Map, 1910. It was not until 1945 that the Chicago system for street numbering was applied to Matteson. Starting with First Street (217th Street) on the south, the numbers became smaller as the streets went north; thus, Second Street became 216th Place and Third Street became 216th Street.

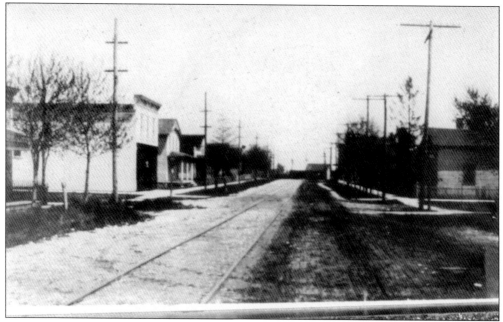

LOOKING EAST DOWN THIRD STREET FROM LOCUST STREET, 1910. Running down the center of the street are the tracks of the interurban line. It was during this year that the village installed its first electric streetlights. Water mains were installed in 1914, and principal municipal streets were paved in 1924. Telephone service became available in 1903.

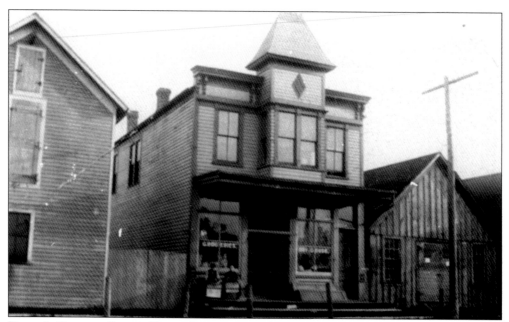

BOYER'S GENERAL STORE, THIRD STREET, 1900. Henry Boyer ran a general store. He was also an avid photographer, taking professional photographs of many street scenes in Matteson. This location later became Roush's Food Store.

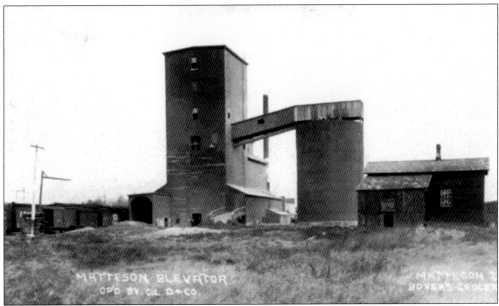

MATTESON ELEVATOR, 1910. Located on the northeast corner of the Illinois Central–Michigan Central crossing, this grain elevator, built in 1890, was an important part of the local economy. To the right is a steel grain tank, and to the left are boxcars waiting to be loaded with grain. This location is now part of the east Metra parking lot.

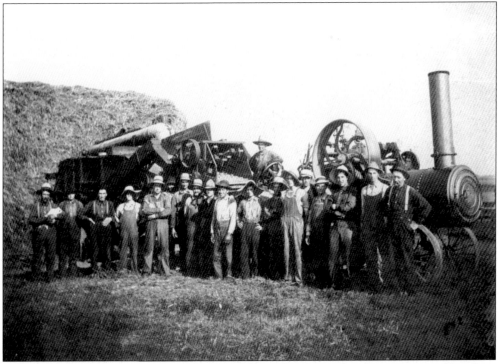

RIEGEL FARM, 1914. During the early part of the 20th century, threshing crews would go from farm to farm bringing in the fall harvest. This farm was owned by George Riegel and is now the site of Lincoln Mall.

JUERGENS FARM. The Juergens family raised corn and soybeans on this land near the corner of Ridgeland Avenue and Vollmer Road between 1910 and 1953. This photograph shows the south side of Vollmer Road, which is now developed with residential housing. Agriculture was a major contributor to the local economy at this time due to the fact that very little industry was being developed in the area.

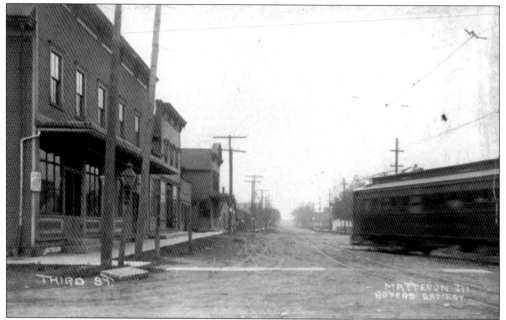

THIRD AND MAIN STREETS LOOKING WEST, 1910. Pictured here from left to right are the Langworth's Tavern/Hotel, F. S. Schroeder Meat Market, and Dettmering's Tavern. The streetlamps on the left were lit and cleaned by the village policeman.

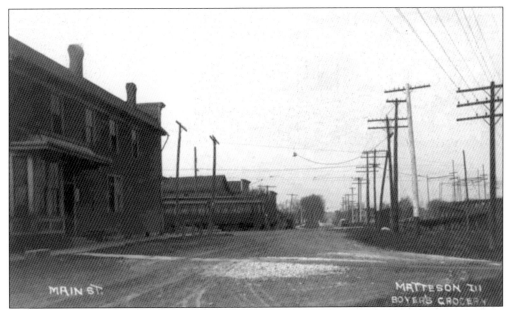

MAIN STREET LOOKING NORTH, C. 1920. This is a view of the interurban streetcar making the turn on Third Street. On the right is the curving trestle that led to the bridge that crossed over both the Illinois Central and Michigan Central railroad tracks. Part of the building on the left was torn down to make way for the new Main Street viaduct being constructed due to the Illinois Central track elevation in 1922. This was the location of Maloni's Tavern.

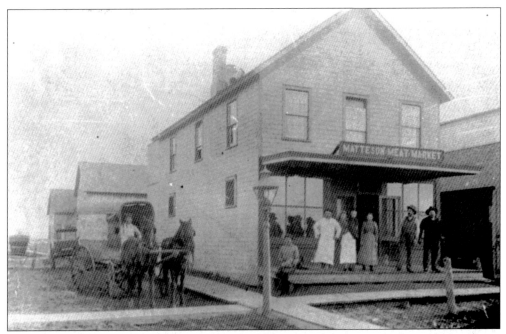

MATTESON MEAT MARKET, 1892. Gustav Grosche operated this meat market at the southwest corner of Third and Locust Streets. He also ran a slaughterhouse just west of where the Wesco plant once stood. An ice storeroom was located on the second floor, with ice being cut from nearby Elliott's pond and pulled up a chute by horses.

MAHLER'S SERVICE STATION, EARLY 1930S. In 1914, Arthur Mahler started his auto garage business, servicing and selling automobiles. He also sold farm implements during this time as well as automobiles manufactured by Mitchell, Maxwell, and Nash. His grandson Tim is carrying on the family tradition today at the same location on the corner of 216th and Locust Streets.

LOUIS MAHLER, 1916. Louis Mahler is sitting down behind the desk looking at a newspaper advertisement for the new 1916 Mitchell automobile selling for $1250 while his grandson Melvin looks on. His son Arthur had just started this business two years before. Louis was previously in the farm implement business.

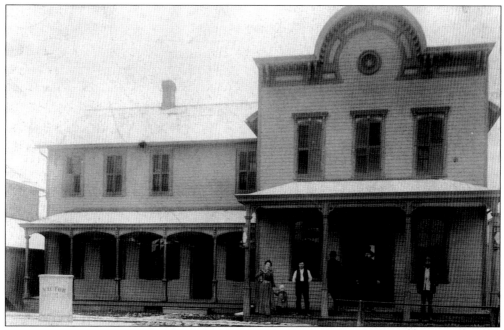

DETTMERING'S TAVERN, C. 1900. Built as the Farmers Hotel in 1880, it later became known as Dettmering's Tavern in 1890 when Heinrich Dettmering purchased the building. In its early days, a scale, seen on the left, was located in front of the tavern to check the weight of the grain that the farmers would take to the elevators in town. Dettmering's Tavern was in the family for three generations and is currently occupied by the Ciao Ristorante.

HENRY DETTMERING. Born in July 1875, Henry Dettmering took over the tavern business from his father, Heinrich, in 1894. Henry was regarded as an authority on politics and an avid sportsman. He served as fire chief for nearly 50 years. All fire calls would be directed to the tavern, with a siren being activated by a switch on the wall. Before this, a bell was rung in front of the village hall and a bucket brigade sprang into action.

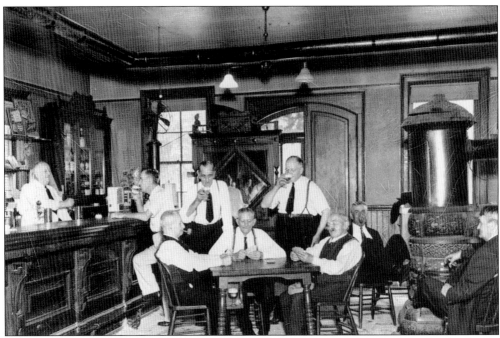

INSIDE DETTMERING'S TAVERN. Dettmering's Tavern was a popular place for the local men of the village to gather to play a game of cards and to talk about the current events of the day. Shown here from left to right are Henry Dettmering, Frank Allemong, Louis Schultz, Rudolph Adams, Charles Polter, and Ed Krabbe. Sitting at the table are, from left to right, Charles Grosche, Charles Krabbe, and Gustav Grosche. Women were not allowed to drink at the bar during this time.

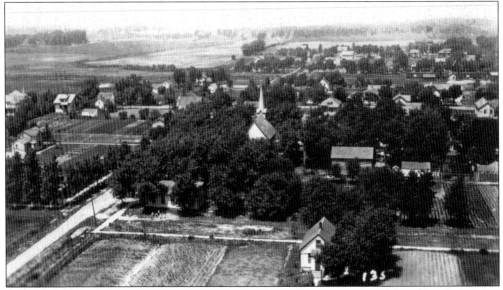

AERIAL VIEW LOOKING NORTH, 1921. This view is looking north from where the Elgin, Joliet and Eastern railroad tracks are located. Children attending Zion Lutheran School can be seen playing behind the school. Pictured in the background is the tall steeple of the church. The tracks of the Michigan Central Railroad can be seen at the top of the photograph.

Two

BUSINESS DISTRICT

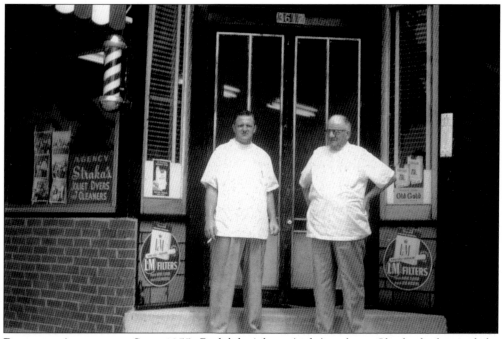

RUDOLPH ADAMS AND SON, 1955. Rudolph Adams (right) and son Charles had served the community since 1894. During the 1950s, business was so good that four chairs were needed, along with three full-time barbers. The family was in the barbershop business for over 50 years.

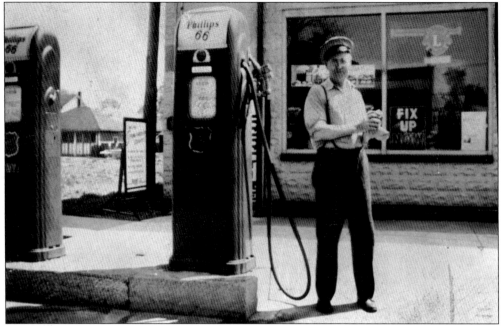

ARTHUR MAHLER. This photograph of Arthur Mahler was taken before he sold his business to his son Melvin in 1953. In the window on the right is a large Lions Club emblem. The elder Mahler was a dedicated member of the Matteson Lions Club, which was organized in 1948. The blind and visually handicapped have always been avidly supported by this organization.

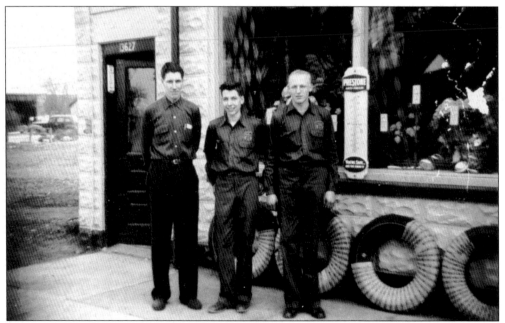

MAHLER'S SERVICE STATION, LATE 1940S. Pictured here from left to right are Melvin Mahler Sr., Melvin Mahler Jr., and Marvin Bode. This photograph was taken at a time when Mahler's repaired automobiles and sold gasoline and automobiles. In the background is the Illinois Central Main Street viaduct.

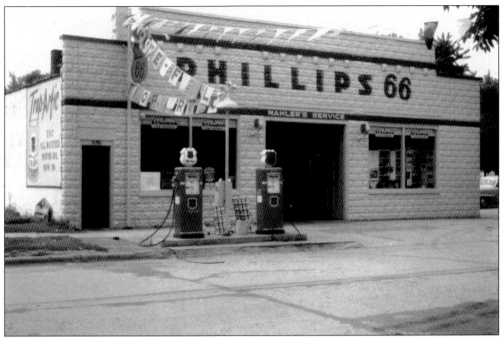

MAHLER'S SERVICE STATION, MID-1950S. This was the original structure built by Arthur Mahler in 1914. The gas pumps at this time were on the 216th Street side of the street, later to be moved to the west side of the station.

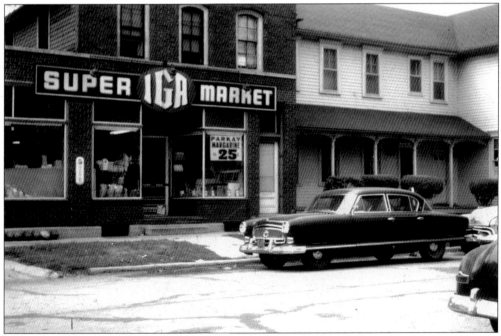

ROEGNER'S IGA GROCERY STORE, 3605 WEST 216TH STREET. This store had many owners and was used for many different businesses. Originally occupied by the F. S. Schroeder Hardware Store, it was an IGA grocery store run by Vernon Roegner by the 1950s.

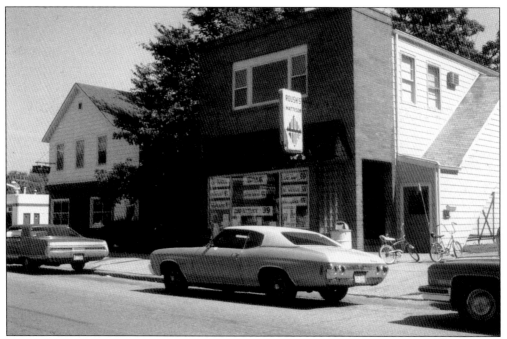

ROUSH'S FOOD STORE, 3705 WEST 216TH STREET. Harry Roush ran this food store from 1962 to the mid-1970s. This was the site of the first house built in Matteson. It was occupied by Charles Ohlendorf, who was the first merchant and postmaster. Gustav Grosche's meat market had formally occupied the building to the left.

WIL AND HELEN'S COFFEE SHOP, 1970s, 3702 WEST 216TH STREET. This building was originally constructed in 1945 by Herman Stege and was known as Kozy Korner for many years. Wil and Helen Niemeyer started a coffee shop in 1968 at this location and ran it until 1981. It is now a hair salon.

MATTESON LUMBER AND COAL COMPANY AND THE ELGIN, JOLIET AND EASTERN TRACKS, MAIN STREET. Philip Hillger and Henry Meinheit became partners in 1916 and the lumber and coal company was a family-owned business until the 1980s. It was well patronized by local residents before the days when chain hardware stores and lumberyards became popular. Coal delivery was an important part of the business in the early days when residents were using coal to heat their homes.

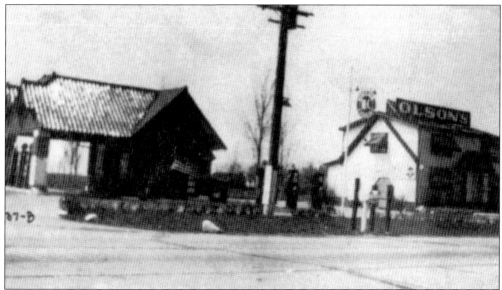

OLSON'S CORNER STORE, 1940s. On the northwest corner of Route 30 and Cicero Avenue stood Olson's Restaurant and Corner Store. This location had served the important east-west transcontinental traffic on the Lincoln Highway. It also catered to motorists traveling to Chicago on Cicero Avenue. Back in the 1930s and 1940s, Cicero Avenue was one of the only direct ways to travel to Chicago. The gas station in front of the restaurant was run by Ed Leinen.

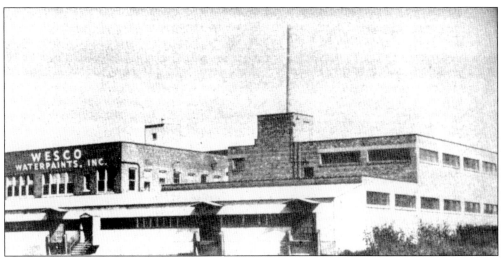

WESCO PAINT PLANT, 1940, END OF MAPLE STREET AT 217TH STREET. This building was built in the 1920s for K. I. Herman Chemical Works. In 1940, Wesco Waterpaints purchased the building. Its last owner was National Gypsum. The factory closed in early 2000. The former slaughterhouse belonging to Gustav Grosche was to the west of the plant along with a baseball diamond.

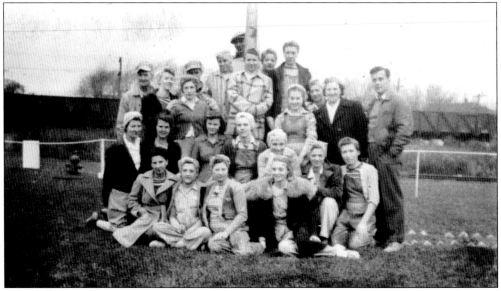

WESCO GROUP PHOTOGRAPH, 1944. This photograph was taken during the World War II years when women were hired in large numbers to do the mixing of water paints. This scene is looking north, with the Elgin, Joliet and Eastern tracks in the background. The man on the far right is Bruno Miniscalco, who was the plant manager for many years. Over 100 employees had worked here by 1955.

Wesco Plant, Mid-1940s. Many local residents were employed here for many years. From left to right are Dan Gallagan, Ruth Gallagan, and Roy Praye, the director of maintenance. This plant was the only location of a factory in the village at the time. Nearby Chicago Heights was the center of industry for the area.

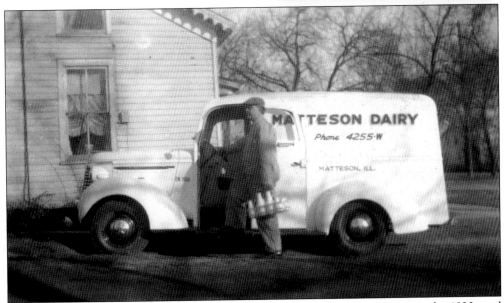

Matteson Dairy, Early 1940s. The village had its own dairy plant between the 1930s and 1950s. It was located on 214th Street near Main Street. The man sitting in the truck is the owner of the dairy, Carl Lauer.

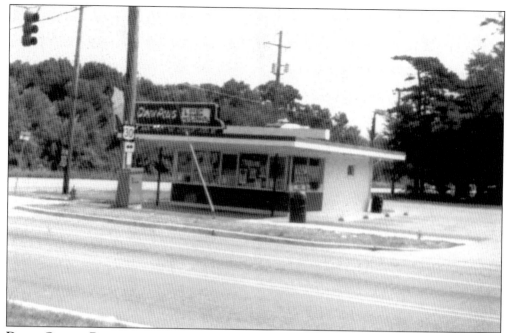

DAIRY QUEEN, ROUTE 30 AND MAIN STREET. In 1955, Fred Lerbs built this structure, which served motorists and local residents until the early 1980s. Lerbs, along with the Wes Grosche family, ran this business until the mid-1970s when it was sold to another party. Later the building was torn down to make way for the Lincoln Highway widening project.

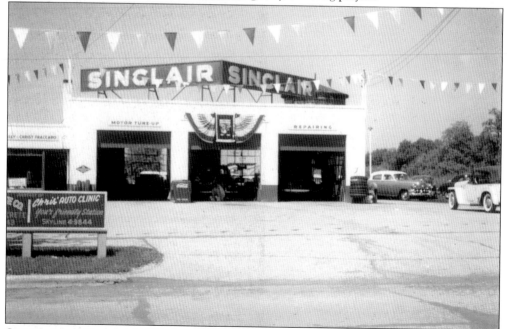

CHRIS' AUTO CLINIC, 21454 SOUTH MAIN STREET. Chris Fraccaro was the owner of this service station, which stood at the pictured site from 1947 to 1972. The station was directly across from the Illinois Central station. Popular movies were shown on the back of the building until the early 1950s.

MALONI'S TAVERN, WEST 216TH AND MAIN STREET. In 1865, this building was constructed as a two-story structure with a hotel on the second floor and a tavern/dental office on the first floor and was known as Langworth's. The building's east half was removed in 1921 for the Illinois Central elevation. The Maloni family was in the tavern business for over 60 years.

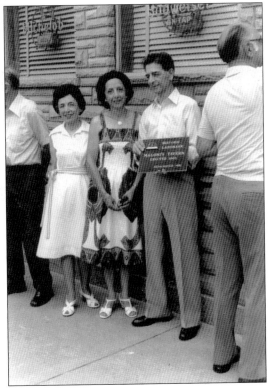

MALONI'S TAVERN, HISTORIC SITE DEDICATION, 1981. In August 1981 Maloni's Tavern was designated a historic site by the Matteson Historical Society. Pat Maloni is holding the designated site plaque with his two sisters, Mary Auman and Stella Cleary, standing nearby. Stella (in white dress) was a longtime teacher at Matteson Public School.

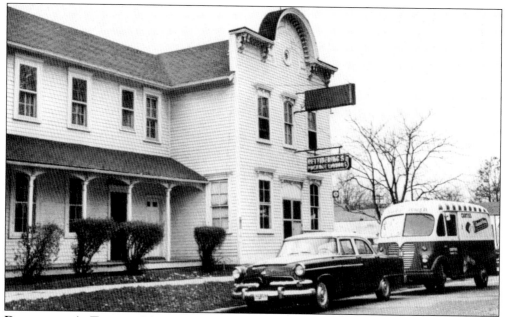

DETTMERING'S TAVERN, MID-1950S. The post–World War II era was a boom time for the restaurant. There was a bigger population in town for the tavern to serve along with the development of neighboring Park Forest. Retail establishments along the Lincoln Highway had yet to be developed, and eventually expansion of the restaurant was a necessity. In 1963, the old Roegner's grocery store was purchased and was annexed to the dining room area.

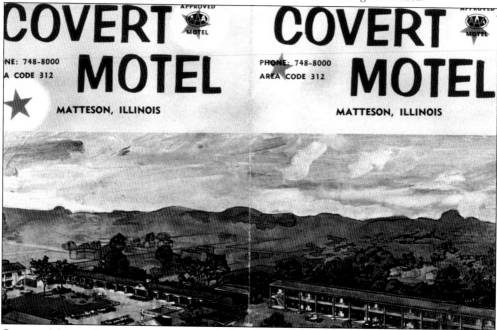

COVERT MOTEL. In 1950, Marvin Covert started this motel at the corner of 216th Street and Route 54 (Governors Highway). During the 1950s, additions were made due to the postwar increase in automobile travel. It offered its guests a swimming pool, bridal suite, kitchenettes, conference room, and a restaurant with colonial charm.

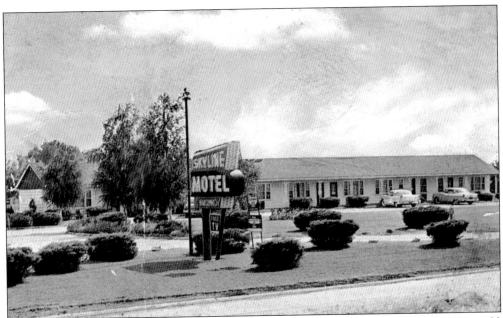

SKYLINE MOTEL, 4343 WEST 211TH STREET, 1954. Several motels were located along Route 30 to capture the growing tourist traffic traveling along the Lincoln Highway in the 1950s. This motel was to the west of the current Matteson Motel and is now occupied by an office building.

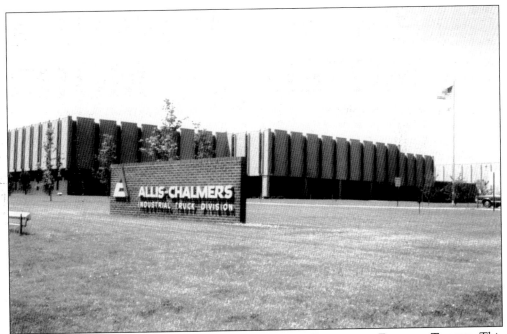

ALLIS-CHALMERS PLANT, CICERO AVENUE AND ELGIN, JOLIET AND EASTERN TRACKS. This plant was opened in September 1970. It manufactured lift trucks until it closed in 1986. The plant was Matteson's largest employer at the time with 1,000 employees. It is currently being used as a storage facility.

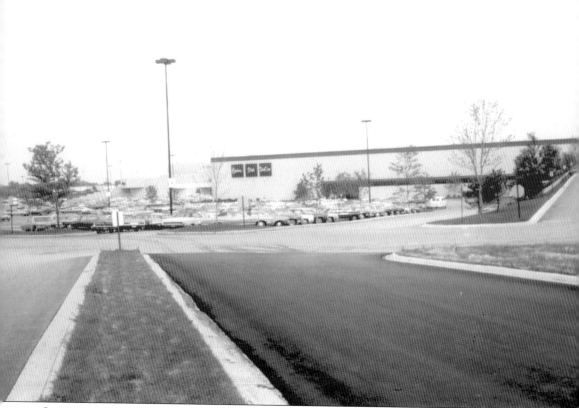

LINCOLN MALL, 1974. Lincoln Mall opened its doors in August 1973. Four major department stores, over 100 specialty shops, and several restaurants provided employment opportunities for more than 3,000 full- and part-time employees.

Three

MUNICIPAL SERVICES

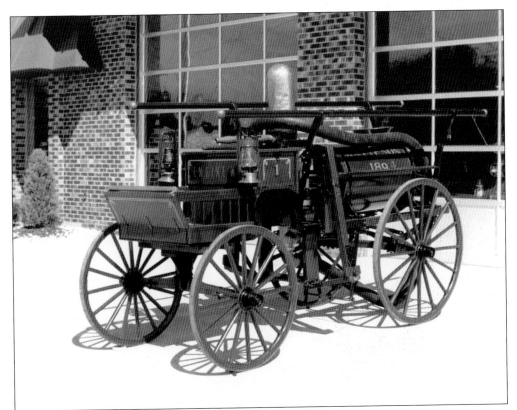

MATTESON FIRE DEPARTMENT, 1894 HOWE PUMPER. This was the first piece of equipment to be purchased by the fire department, a hand-drawn chemical and water hand pumper. The funds for the purchase came from member donations, resident contributions, and fund-raising activities. No tax money was used at the time for such acquisitions.

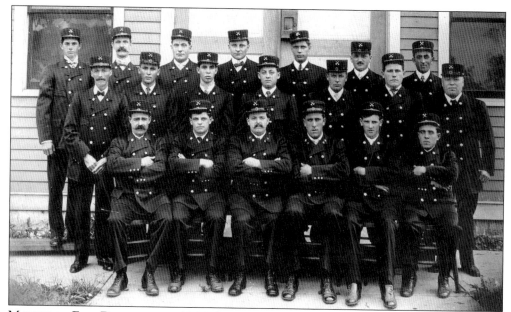

MATTESON FIRE DEPARTMENT, 1906. In 1894, the Matteson Volunteer Fire Department was organized. In 1897, the first firehouse was built as part of the new village hall. An alarm bell was rung in the belfry of the village hall to alert firemen to come to the firehouse and take the hand pumper to wherever the fire might be in the village. Among those pictured here are Fred Claussen, Fred Malo, Henry Boyer, William Schalong, Rudolph Adams, Charles Polter, Fred Schultz, Charles Traubee, Albert Reese, Albin Hoag, August Schroeder, Charles Minge, Charles Weiss, Louis Dettmering, Henry Dettmering, Louis Schultz, Gus Venske, and William Schultz.

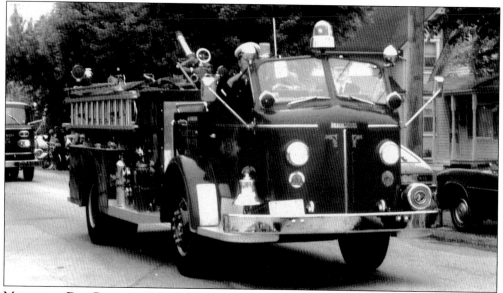

MEMORIAL DAY PARADE, 1976. Matteson fire engine No. 3 was the first postwar fire engine purchased by the department. It was a 1957 American LaFrance 1,000-gallon pumper and was in use until 1991. Olympia Fields has also been in the Matteson fire district for many years and has helped to support the purchase of fire apparatus.

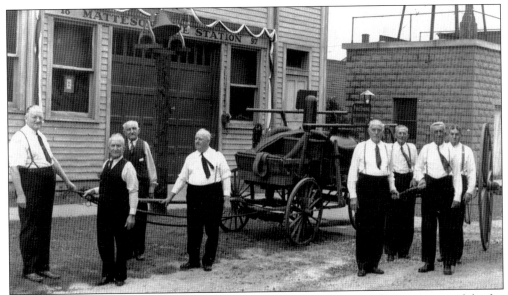

MATTESON FIRE DEPARTMENT, 50TH ANNIVERSARY. In 1944, the 50th anniversary of the fire department was celebrated with a big parade. Veteran firemen gathered for a photograph by the 1896 hand-drawn hose cart and hook and ladder unit. Pictured from left to right are Rudolph Adams, Gustav Grosche, Charles Grosche, Henry Dettmering, Henry Boyer, Charles Krabbe, Charles Polter, and Ed Krabbe.

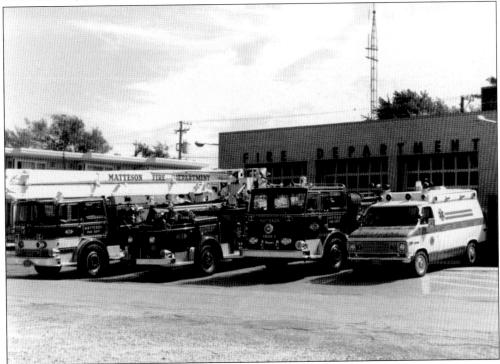

MATTESON FIRE STATION NO. 1, 1975. Fire station No. 1 was located at the intersection of 215th and Locust Streets between the years of 1948 and 2003. Expansion was needed to accommodate better living quarters, office space, and more equipment.

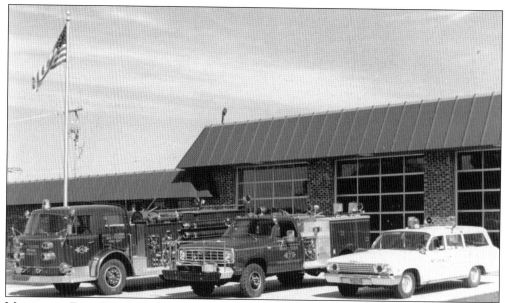

MATTESON FIRE STATION NO. 2, 1975. Fire Station No. 2 stands near the intersection of Central Avenue and the Lincoln Highway. It was built in 1973 to serve the new subdivisions and commercial establishments on the west side of the village. Since its inception, the department has served a large area. The boundaries of the neighborhood that the department once served were Harlem and Steger Roads on the west, Western Avenue and Exchange Street on the east and south, and Vollmer Road on the north. The village of Olympia Fields is also served by the Matteson Fire Department on a contractual basis.

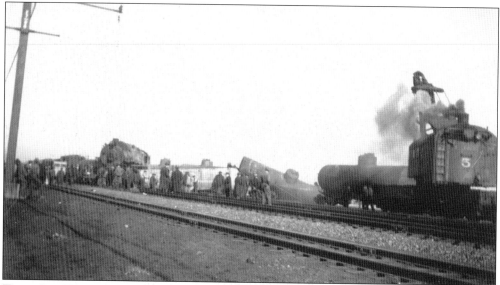

TANK CAR EXPLOSION, 1943. The Matteson Fire Department fought one of its worst fires in its history when on February 22, 1943, three freight trains collided, resulting in loaded tank cars exploding on one train. The collision was where the Illinois Central and Michigan Central Railroads interchanged cars. The fire was so intense that it burned the copper off the nearby suburban electric line. Boy Scouts, under the direction of Wilbur Ellis (later the police chief in Matteson), helped firemen lay hoses and keep curious onlookers away from the blaze.

42

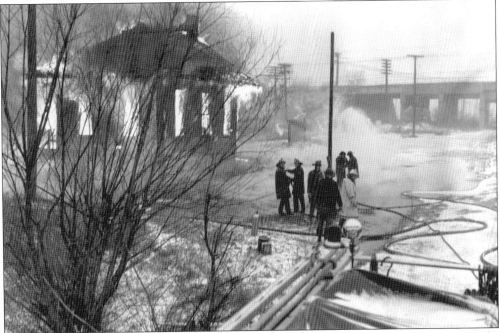

FIRE EXERCISE, 1964. In January 1964, the fire department had staged a practice fire at the abandoned Michigan Central freight station on Front Street. Water ball fights were held for many years in front of the village hall to give firemen practice in fire hose techniques.

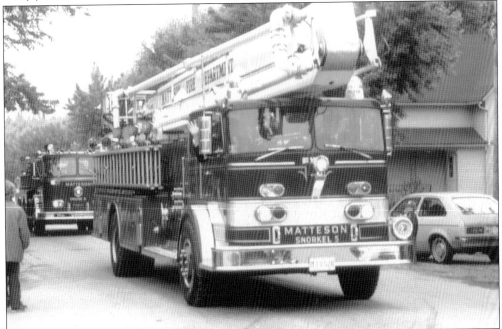

SNORKEL NO. 5, MEMORIAL DAY PARADE, 1976. A 75-foot snorkel was the pride of the department when it was purchased for the amount of $75,000 in 1967. It was acquired for the protection of the multilevel structures that were being constructed in the village. The snorkel was also helpful in assisting in mutual aid calls to nearby communities. It was sold in 1988.

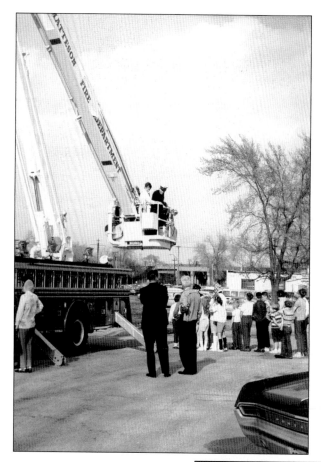

SNORKEL DEMONSTRATION 1967.
The department was generous in giving schoolkids and residents rides in the basket of the snorkel. Chief Larry Vollmer can be seen in the basket with a group of riders as village president Joseph Feehery (in dark suit) looks on.

FIRE DEPARTMENT AUXILIARY, MEMORIAL DAY, 1971.
Organized in 1949, the Matteson Fire Department Auxiliary was formed to better help the community in regards to the fire department. The auxiliary's early role was to serve coffee and doughnuts to the men who were fighting a major fire. From left to right are Jane Metzger, Sue Schoeling, Diane Coulon, Mary Campe, Joy Barwig, Terri Johnson, and Ruth Gericke. Kay Grosche (not shown) was one of the founding women of the group.

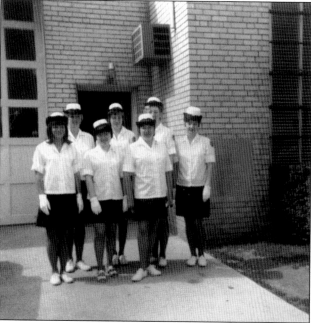

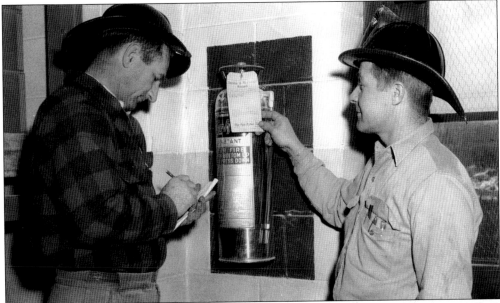

FIRE EXTINGUISHER INSPECTION, 1950s. Part of the duties of the fire department was to check the condition of fire extinguishers in public places. Seen here are Leroy Harms (left) and Roy Praye carrying out these responsibilities. Not until the mid-1970s were full-time firemen hired in the village. All of the firemen were volunteers during this era.

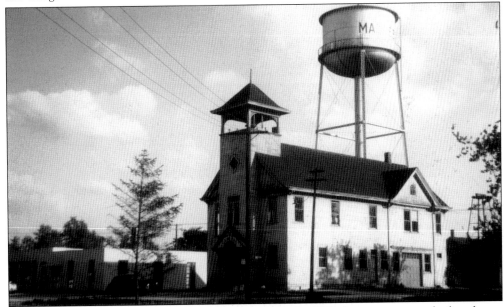

VILLAGE HALL, 215TH AND LOCUST STREETS, 1948. In 1897, this structure was built to house the village hall and the police and fire departments for a cost of $3,225. The building also served as a gathering point for dances and other festivities. The bell in the belfry tower served as a signal to summon the firemen to the firehouse. The bell was removed at the time of demolition and later used as a memorial to former mayor Frank Allemong in 1958 at the site of the old village hall. In 1949, some of the foundation stones were used in the military memorial at Memorial Park. To the left can be seen the new village hall.

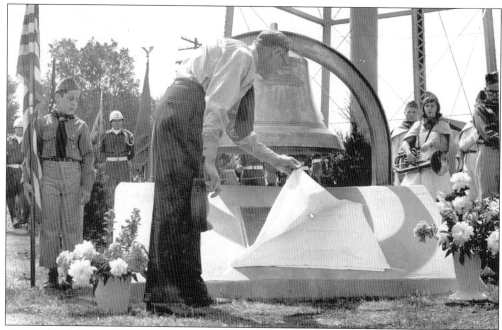

ALLEMONG MEMORIAL BELL, 1958. On May 30, 1958, the old village hall bell was dedicated to the memory of Frank Allemong, who was village president for 21 years. The site was where the former village hall had stood. Every Memorial Day, the bell is rung by a former president of the Lions Club.

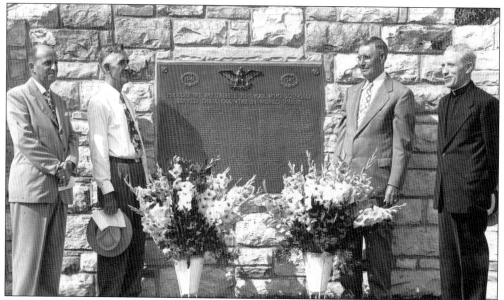

DEDICATION OF MEMORIAL PARK, 1949. On August 28, this memorial, which shows the names of the 177 Matteson area servicemen who served in World War II, was dedicated. The stones that supported this plaque came from the foundation of the 1897 village hall. Shown from left to right are a legion official; Frank Allemong, the village president; Arthur Mahler, the first commissioner of parks and recreation; and Rev. Herman P. Meyer, the pastor of Zion Evangelical Lutheran Church.

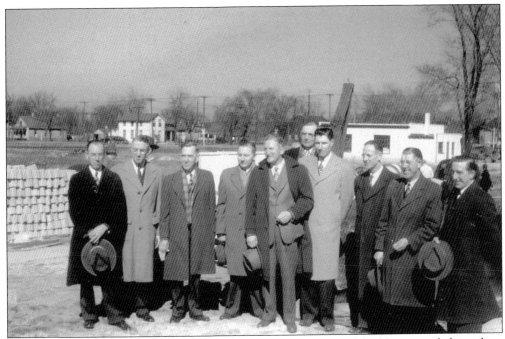

1948 VILLAGE HALL DEDICATION. The new $55,000 municipal building was dedicated on August 29, 1948, at the corner of Locust Street and 215th Street. Village officials on hand for the event were, from left to right, Fred Schoeling, Dr. Willis Schmeckebier, Frank Allemong, James Shaw, M. P. Komar, William Mahler, Melvin Mahler, Oscar Dettmering, Fred Lerbs, and Henry Dettmering.

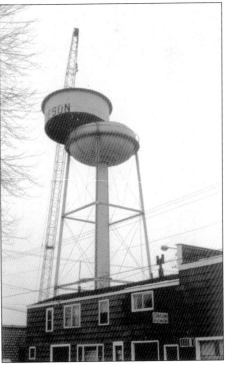

MATTESON WATER TOWER, 1972. In 1914, this 100,000-gallon water tower was constructed at a price of $4,700. This photograph shows the structure being dismantled in February 1972. For many years, lit stars that encircled the catwalk were turned on during the Christmas season. These lights were installed courtesy of the Lions Club.

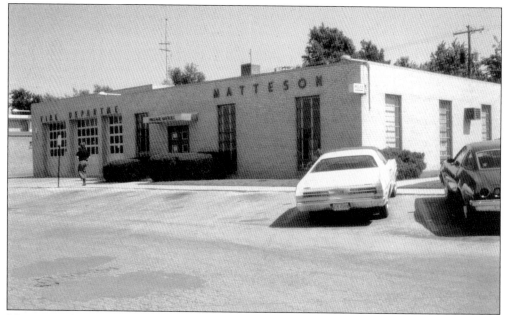

MATTESON MUNICIPAL BUILDING, 1974. This facility served the community as the police station until 1987 and village hall until 1999. The fire department vacated it for a new facility on Lincoln Highway in 2003.

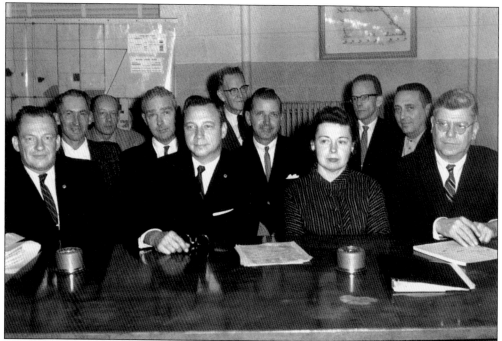

VILLAGE OFFICIALS, 1961. This photograph shows village trustees and officials attending a board meeting in December 1961. Pictured from left to right are (first row) Bill Owler, Joseph Feehery (village president), Marcella Melvin (village clerk), and Henry Lehman (village attorney); (second row) Walter Meyer, unidentified, Bob Jahn, and Bill Howard; (third row) George Barber, Oscar Dettmering, and Ira Hardman.

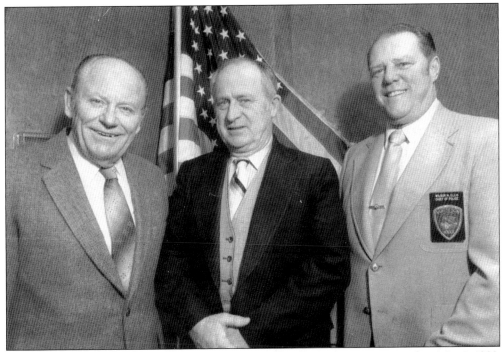

RETIREMENT OF VILLAGE DEPARTMENT HEADS, 1983. These three men retired on May 1, 1983, and had a combined service of over 75 years to the community. They are, from left to right, Lawrence Vollmer, fire chief; Roy Jung, superintendent of public works; and Wilbur Ellis, chief of police.

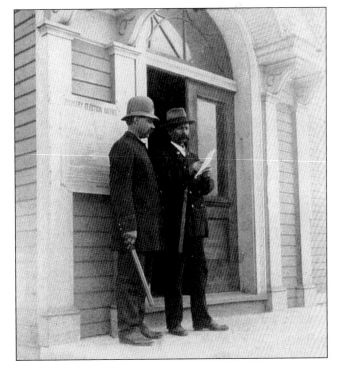

JOHN UMLAND, MATTESON POLICE DEPARTMENT, C. 1910. One of the earliest photographs of a Matteson police officer shows John Umland on the left standing next to a village official in front of the village hall. The police department and two jail cells were also housed in this building. Umland was also a blacksmith in town.

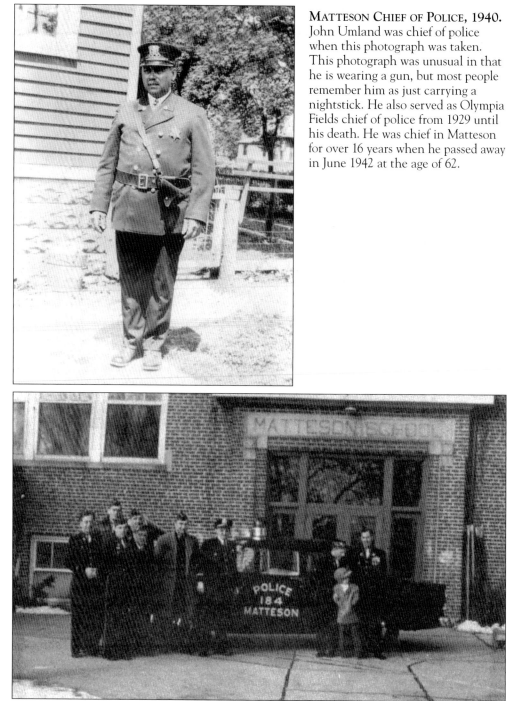

MATTESON CHIEF OF POLICE, 1940.
John Umland was chief of police when this photograph was taken. This photograph was unusual in that he is wearing a gun, but most people remember him as just carrying a nightstick. He also served as Olympia Fields chief of police from 1929 until his death. He was chief in Matteson for over 16 years when he passed away in June 1942 at the age of 62.

POLICE CAR PRESENTATION, 1954. American Legion Rehfeldt-Meyer Post 474 provided many benefits to the community, donating equipment to the fire and police departments since the 1940s. This ceremony is showing the presentation of a police car to the village in front of the public school in December 1954. This was taken at a time when the village government was not involved in the acquisition of equipment used by the police or fire departments.

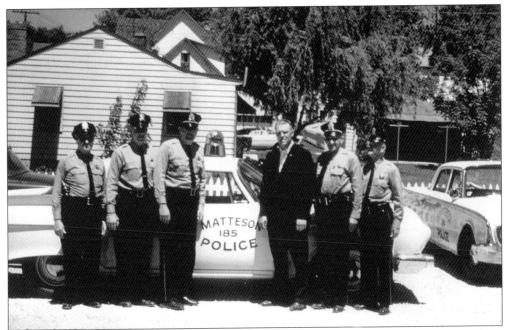

POLICE CAR PRESENTATION, 1962. A police car was presented to the village by the post in front of the American Legion hall in 1962. Police officers from left to right are Sgt. William Stroup, officer Harold Young, Lt. Richard Dykstra, Chief Wilbur Ellis, Sgt. Jacob DePorto, and officer Carl Kaufman. Matteson police provided protection for Olympia Fields on a contract basis until 1962.

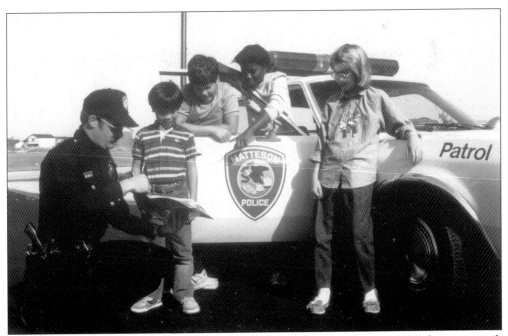

POLICE WORKING IN THE COMMUNITY, 1985. Part of the police department's duty is to work with area schoolchildren on various issues concerning safety and drug abuse. Officer Tom Dermody is shown talking about such issues with a group of students.

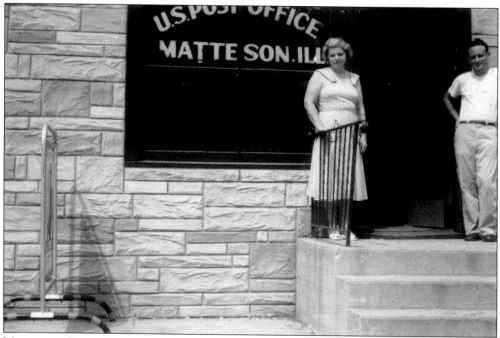

MATTESON POST OFFICE, MID-1950S, 21504 SOUTH MAIN STREET. Postal clerk Margaret Luering and postmaster Ray Letourneau are posing for moving day from the location at the corner of 215th Street and Main Street to the corner of 216th Street and Locust Street.

MATTESON POST OFFICE, 1990. In 1990, the post office was moved to a new facility on Cicero Avenue. This building was dedicated in 1962 under an aggressive building program undertaken by the U.S. Postal Service during the Kennedy administration. It was located at the corner of 216th Street and Maple Street. This picture was taken on the last day of operation at this facility. Pictured from left to right are Georgeanne Wise, Rudolph Morgan, Robert Tedy, Joseph Schmitt, and Norman Kampe.

Four

PARADES

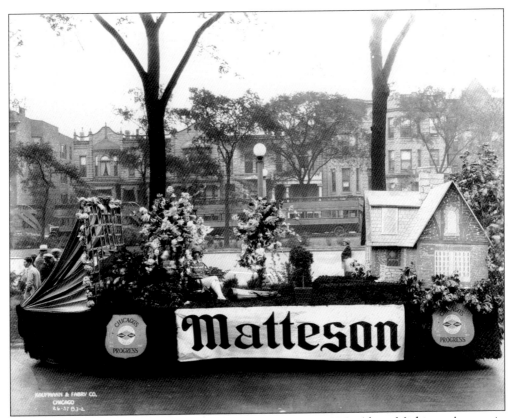

ILLINOIS CENTRAL ELECTRIFICATION PARADE, AUGUST 1926. Along Michigan Avenue in Chicago stands Matteson's entry in the parade that was held in August 1926 celebrating the electrification of the Illinois Central suburban service. Elsie Dettmering held the crown of "Miss Matteson" on the float. Other communities along the Illinois Central also had entries in the parade, which totaled over 450 floats.

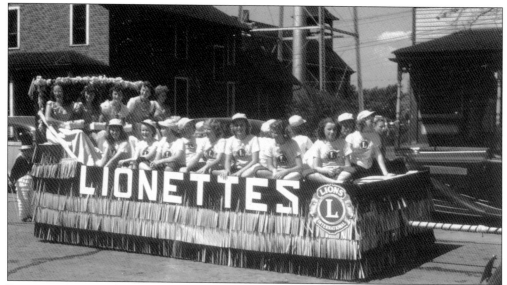

LIONETTES FLOAT, LATE 1940S. The Lionettes was a girls' club sponsored by the Lions Club and was involved in athletic activities. Matteson Lions also raised funds for many community-benefiting acquisitions, like radios for the police department and resuscitators for the fire department. It was during this time that the Lions Club International purchased land east of the Illinois Central tracks for a planned community called Liondom that would cater to its membership. The project did not materialize, and the land was sold to developers who built the Lincolnwood section of Park Forest.

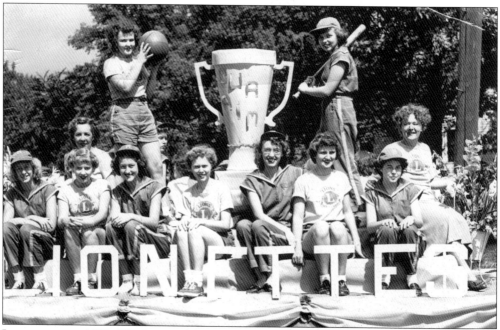

LIONETTES, C. 1950. The Lions Club sponsored this softball team in a Memorial Day parade in the early 1950s. Shown from left to right are (first row) Janet Vollmer, Kay Guilotte, Marilyn Stege, Loretta Lages, Barbara Scharnhorst, Betty Dexter, and Carol Woodruff; (second row) Ruth Turner, Miriam Becker, unidentified, Dorothy Becker, and Marie Lages (coach).

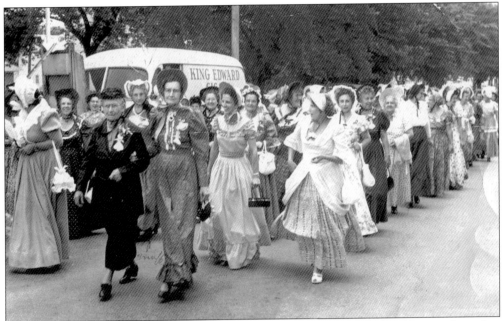

SISTER OF THE SWISH, 1955. During the centennial of 1955, many village women dressed in old-fashioned clothing to commemorate the event. The "sisters" had to promise that they would always wear their old-fashioned clothing while attending village functions.

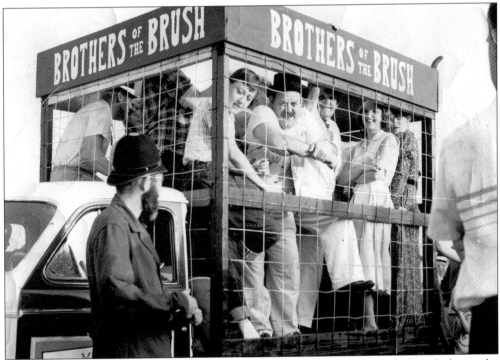

BROTHERS OF THE BRUSH, 1955. Men of the village were encouraged to grow beards during the centennial or be thrown in "jail" for five minutes as punishment. A contest was held to see who had the thickest beard. The contest was won by John Gericke (not shown).

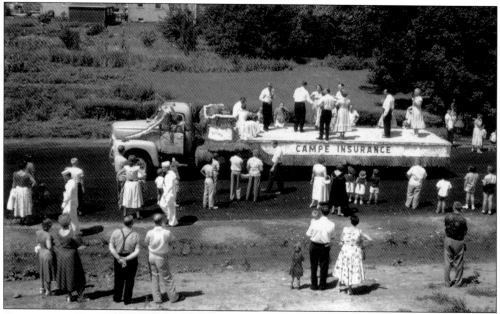

CENTENNIAL PARADE, CAMPE INSURANCE FLOAT. This float featured couples doing live square dancing in front of parade watchers. Campe Insurance occupied the old German American Bank from 1952 until the 1980s.

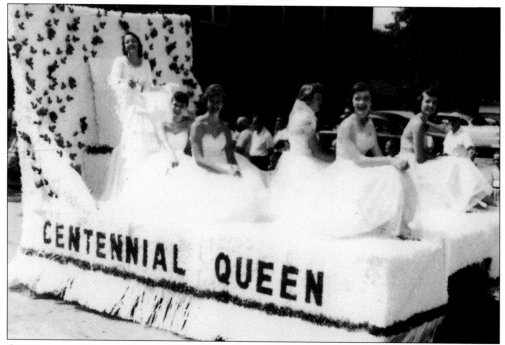

CENTENNIAL QUEEN FLOAT. Over 15,000 spectators were reported to have watched this ceremonious parade. Sonia Schmeckpeper was crowned Miss Matteson for this event and can be seen to the far left on the float. The rest of her court, from left to right, are Barbara Lages, Arlene Stuenkel, Velma Trenary, Judy Morell, and Myrna Braun. The village had a population of 2,500 residents during this celebration.

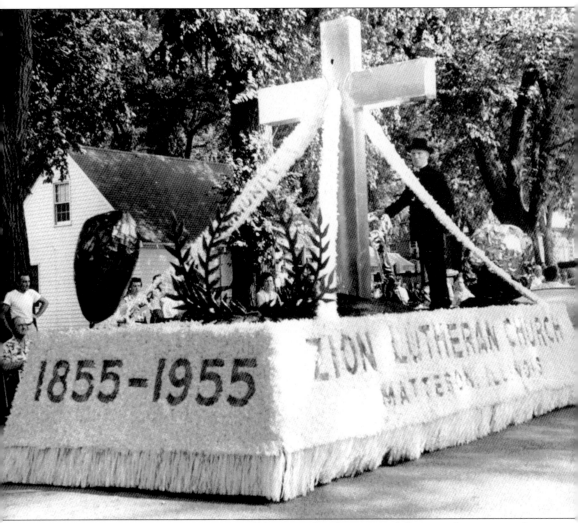

ZION LUTHERAN FLOAT, 1955. Many of the area churches entered floats in the centennial parade, including Zion Lutheran. Rev. Herman P. Meyer can be seen standing on the float. He served the Zion congregation from 1942 to 1957.

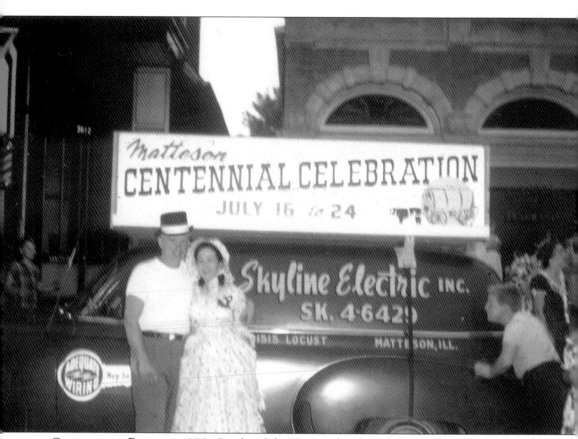

CENTENNIAL PARADE, 1955. Sunday, July 17 was the day of the centennial parade. The celebration lasted a week, with events schedule every day. This photograph shows Marv and Hanna Young, the owners of Skyline Electric, posing in front of what was the old German American Bank building. This was also the same year that neighboring Frankfort was celebrating its centennial.

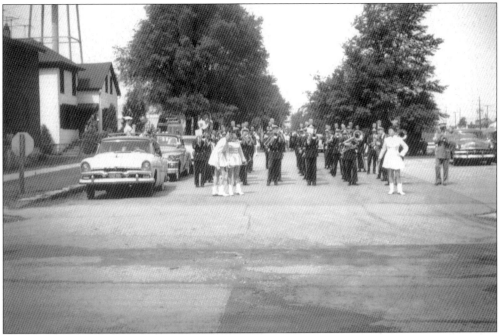

MEMORIAL DAY PARADE, 1957. Area high school bands were active participants in the parade. One of these bands is at the corner of 215th Street and Main Street, where the parade began. The American Legion Rehfeldt-Meyer Post 474 has sponsored this event since 1932.

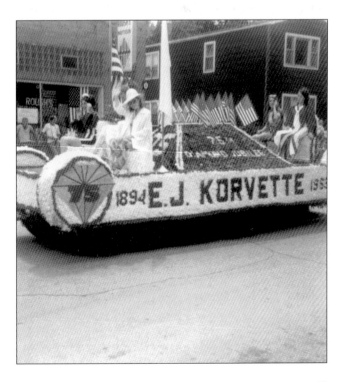

MATTESON FIRE DEPARTMENT 75TH ANNIVERSARY PARADE, 1969. This was one of the largest parades in the history of the village. E. J. Korvette was a popular department store located on the northwest corner of Crawford Street and Route 30. It opened its doors in 1963 and was in business until the late 1970s.

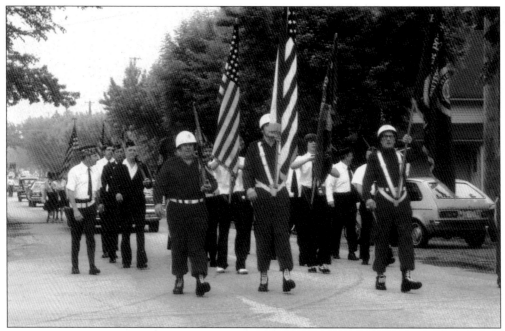

MEMORIAL DAY PARADE, 1976. Leading the parade is the traditional American Legion color guard in the year of the American Bicentennial. The color guard is shown marching down Main Street. Parade routes through the years have taken different routes. At one time, it followed Main Street to Lincoln Highway then west to the cemeteries. Since the 1950s, a common route takes 216th Street to Maple Street, then north to the cemeteries.

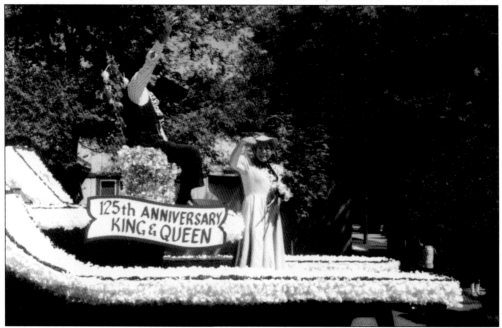

MATTESON'S 125TH ANNIVERSARY CELEBRATION, 1980. Senior Citizen Queen Margaret Luering and King Arthur Anderson were chosen in a contest that was sponsored by the American Legion Auxiliary of Matteson. The celebration ran from August 22 to August 24.

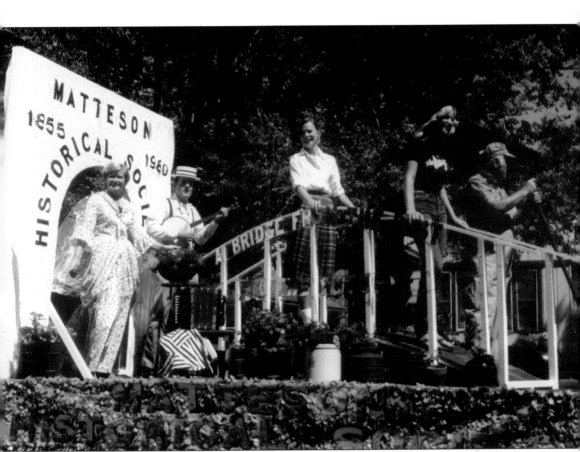

ANNIVERSARY FLOAT. The Matteson Historical Society sponsored this float in the parade on August 24. More than 35 entries from Matteson and surrounding communities participated. At this time, the village had a population of over 10,000 residents.

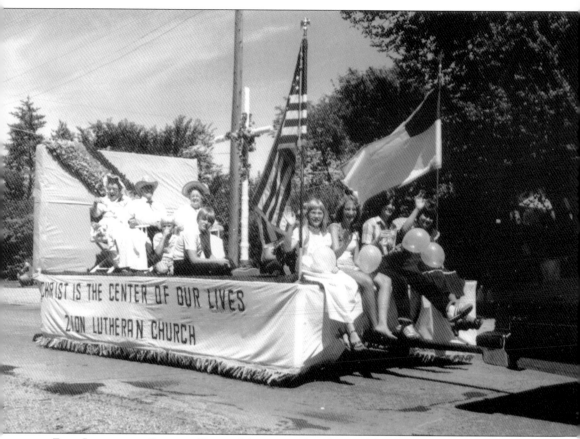

ZION LUTHERAN CHURCH FLOAT. Many area churches and businesses prepared floats for the parade commemorating the 125th anniversary. Zion Lutheran Church is the oldest congregation in Matteson.

Five

CHURCHES AND
CIVIC ORGANIZATIONS

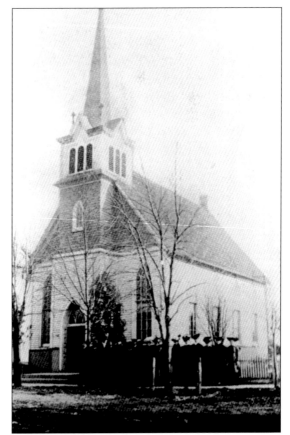

ZION EVANGELICAL LUTHERAN CHURCH, 1889. Zion Lutheran Church was formed in 1878 and used the school building that was constructed in 1868 to conduct services. In 1889, its first church building was constructed next to the schoolhouse at the corner of 216th Place and Maple Street. This picture shows the original church as built with the 80-foot steeple. The new building cost $2,900 to build.

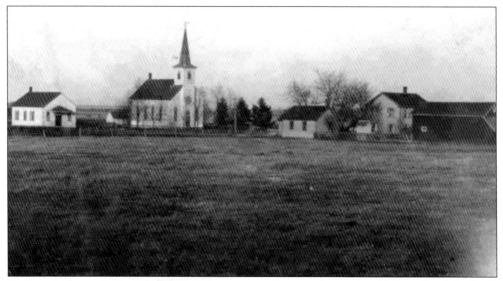

ST. PAUL'S EVANGELICAL LUTHERAN CHURCH AND SCHOOL. Located on Vollmer Road, St. Paul's Evangelical Lutheran Church was built in 1883 at a cost of $3,500 to serve Matteson's rural population. On the far left is the Sieden Prairie Public School, erected in 1869, and across the street is the German Lutheran School, built in 1875. Students attended the German Lutheran School four days a week in the morning for religious instruction. They went to the public school in the afternoons on these days and attended the public school for a full day on Friday.

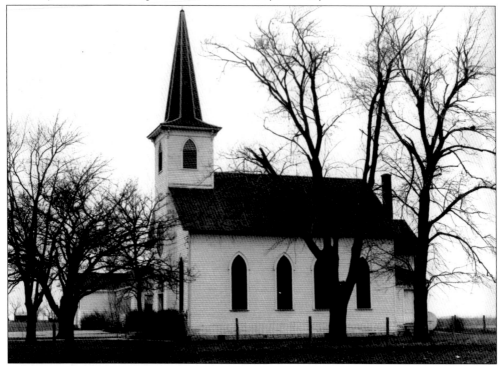

ST. PAUL'S EVANGELICAL LUTHERAN CHURCH, 6200 VOLLMER ROAD. Constructed in 1883, this building served the congregation until a new building was erected across the street in 1996. Church services were conducted in German until the first English service was spoken in 1935.

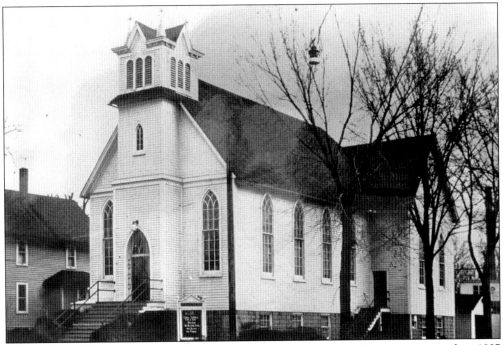

ZION EVANGELICAL LUTHERAN CHURCH, 1927. The church building was renovated in 1927 and moved on rollers to exchange places with the parsonage, which stood at the corner of 216th Place and Maple Street. The renovation cost $19,000 and included a new basement, new bell, and new altar. The steeple was removed because of its poor condition.

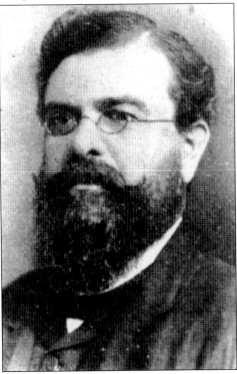

GOTTLIEB TRAUB, 1878. Zion Evangelical Lutheran's first pastor served the congregation for just one year. His home was in Crete, Illinois, so once a week he rode a horse and buggy to serve the congregation in Matteson.

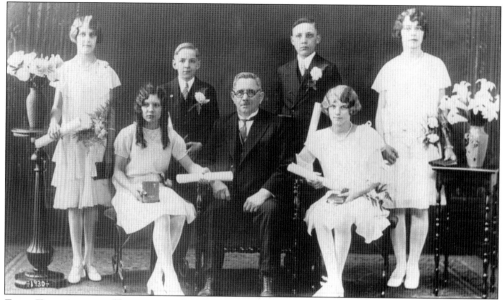

ZION EVANGELICAL LUTHERAN CONFIRMATION CLASS, 1930. Confirmation was taught in German by Pastor Christopher Becker. He enjoyed playing the violin and telling stories with a moral message. He served Zion from 1905 to 1937. Confirmands are, from left to right, (seated) Evilena Wolter, Pastor Becker, and Lorna Marquardt; (standing) Harriet Patteson, Gerhardt Becker, Clarence Von Berge, and Ellen Jahn.

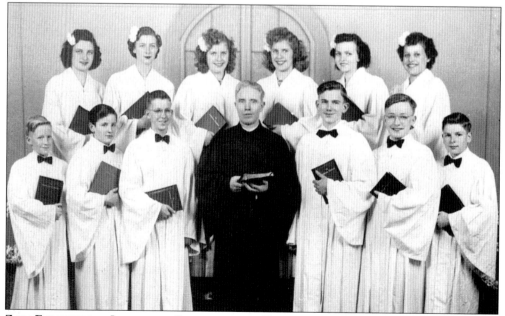

ZION EVANGELICAL LUTHERAN CONFIRMATION CLASS, 1948. Confirmation was a time when young men and women in the eighth grade renewed their baptismal vows. Herman P. Meyer was pastor of Zion from 1942 to 1957. Shown here, from left to right, are (first row) David Meyer, Delmar Albers, William Hansen, Pastor Meyer, Dennis Hill, Vincent Schmeckpeper, and Edward Leinen; (second row) Darlene Braun, Joanne Ehrhardt, Kay Guilotte, Joan Guilotte, Miriam Becker, and Betty Boettger.

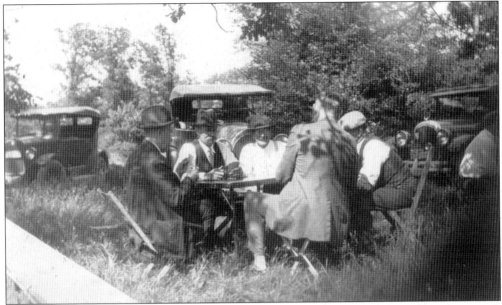

CHURCH PICNIC, 1925. Card playing was a popular pastime in the 1920s. This photograph shows a group of men from Zion Evangelical Lutheran Church playing a card game at the Lustfeldt farm, which was located on Sauk Trail.

ZION EVANGELICAL AND REFORMED CHURCH. In 1916, this congregation was formed as an outgrowth of St. Paul's Evangelical Church in Richton Park. The name chosen was Evangelical Zion Church of Matteson and a new basement church was built in 1917 at the corner of Main Street and 213th Place with the intentions of building an upper structure. In 1955, the name was changed to Faith Church, Evangelical and Reformed, to eliminate confusion with the Zion Evangelical Lutheran Church in Matteson.

FAITH CHURCH, 1957. In September 1957, a new structure was dedicated at the corner of 213th Street and Maple Street at a cost of $100,000. The congregation was growing at a fast pace due to the growth of population in the village during the 1950s. The decision was made to build a new church structure in the mid-1950s.

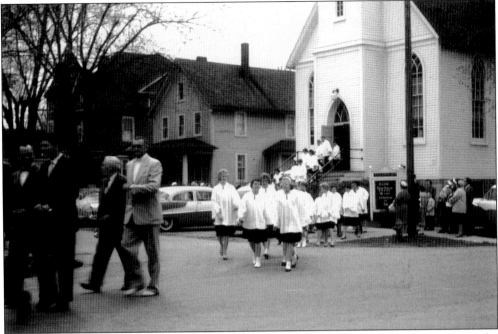

ZION LUTHERAN DEDICATION, 1961. The week of May 7, 1961, was dedication week for the new church and school. Pastor Fred Van led the congregation for a walk to the new church site after giving a farewell service at the old church building.

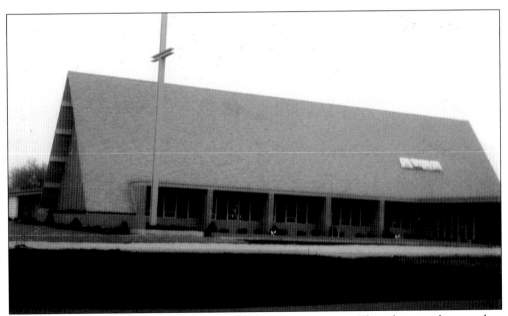

ZION LUTHERAN CHURCH, 1961, 3840 WEST 216TH STREET. This photograph was taken right after the dedication of the new church in May 1961. Groundbreaking took place in March 1960 under the direction of Rev. Fred Van.

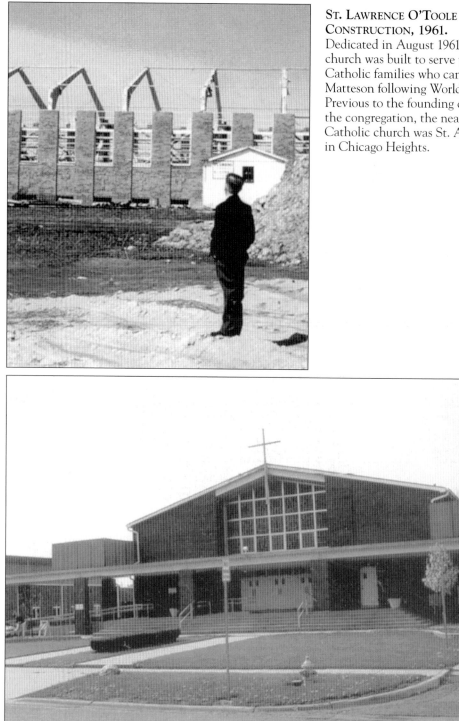

St. Lawrence O'Toole Construction, 1961. Dedicated in August 1961, the church was built to serve young Catholic families who came to Matteson following World War II. Previous to the founding of the congregation, the nearest Catholic church was St. Agnes in Chicago Heights.

St. Lawrence O'Toole. Ground was broken in August 1960 and was completed one year later. Fr. William Doran was named the first pastor. The church is located west of Governors Highway on Lawrence Avenue.

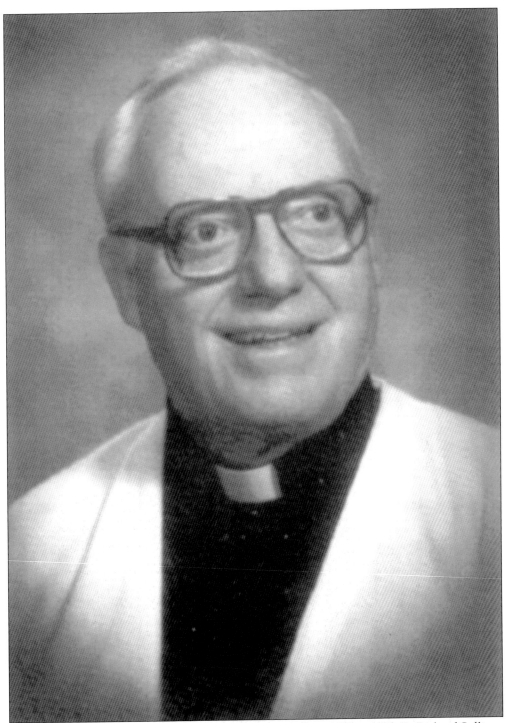

FATHER SULLIVAN. The pastor of St. Lawrence O'Toole from 1971 to 1988, Fr. Richard Sullivan was born on April 22, 1918, and spent his childhood in Maywood. He was loved by his parishioners and was known as a spiritual counselor, friend, and devout White Sox fan. He passed away on July 14, 1990. In November 1993, a new parish center was named after him.

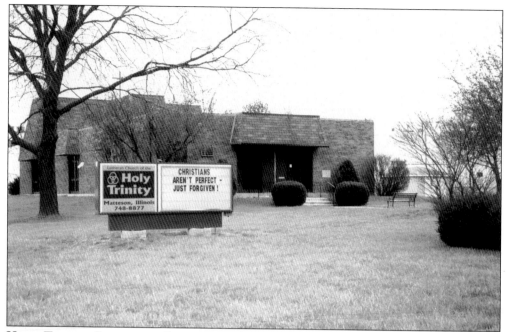

HOLY TRINITY LUTHERAN CHURCH. Dedicated on December 17, 1967, Holy Trinity at Lindenwood Drive and Crawford Avenue was known for a Civil War–type encampment that was held once a year along with a 1860s worship service. The building is now occupied by another Christian congregation.

IMMANUEL EVANGELICAL LUTHERAN CHURCH. In 1852, this congregation was the first to form in the Matteson area. Many of the first German immigrants to come here were members of this church. Zion Evangelical Lutheran Church was an outgrowth of Immanuel because residents did not care to walk the long distance of over two miles to reach the church at the corner of Sauk Trail and Cicero Avenue. This photograph shows the present church structure, which was dedicated in June 1962.

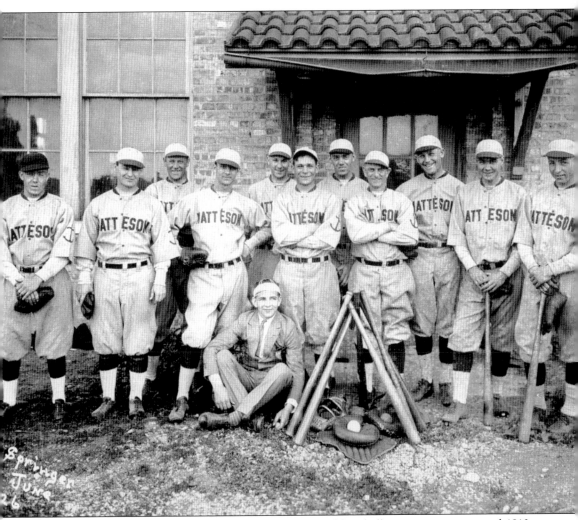

MATTESON ANCHORS, 1926. The village had organized baseball teams starting around 1910. The teams were known as the Anchors, Boosters, and Bears. Baseball diamonds were located just west of the old National Gypsum plant and off Route 30 where the present Hirsh Funeral Home is located. Shown here are, from left to right, (sitting) umpire Oscar Becker; (standing) unidentified, Floyd Windal, Bill Schafer, "Lefty" Delamata, Arthur Schafer, Frank Schafer, Lawrence Schramm, Charles Sorensen, Bill Ehrhardt, Cliff Weiss, and Butch Grosche.

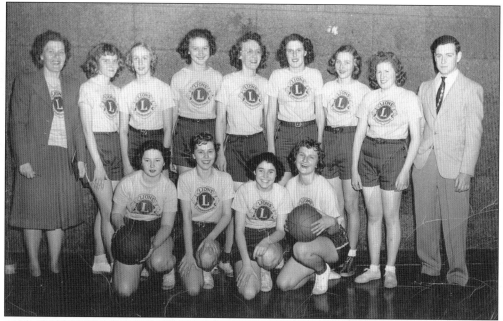

LIONETTES BASKETBALL TEAM, LATE 1940S. The Lionettes was a girls' athletic club sponsored by the Matteson Lions Club. Pictured here are, from left to right, (first row) unidentified, Loretta Lages, Carol Woodruff, and Betty Dexter; (second row) leader Marie Lages, Ruth Dettmering, Janet Vollmer, Marilyn Stege, Barbara Scharnhorst, Margaret Werling, Joanne Ehrhardt, Louise Jones, and William Metzger.

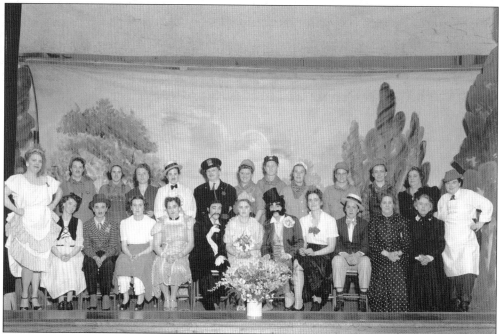

PARENT-TEACHERS ASSOCIATION PLAY, 1944. Play productions were part of life in Matteson throughout the 1940s, 1950s, and 1960s. This is the cast of *Love Rides the Rail*, given by the Matteson Public School Parent-Teacher Association.

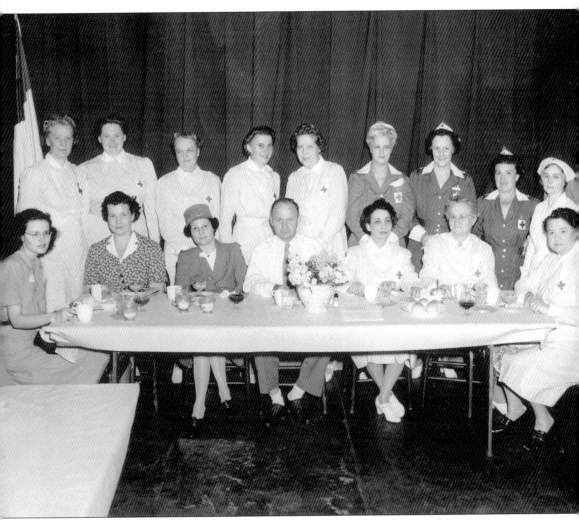

RED CROSS WORKERS, 1942. Women from the community were showing their patriotic spirit by volunteering for Red Cross service during World War II. Lenore Dettmering, who for many years wrote the "Matteson News" column in the *Chicago Heights Star* newspaper, is standing second from right.

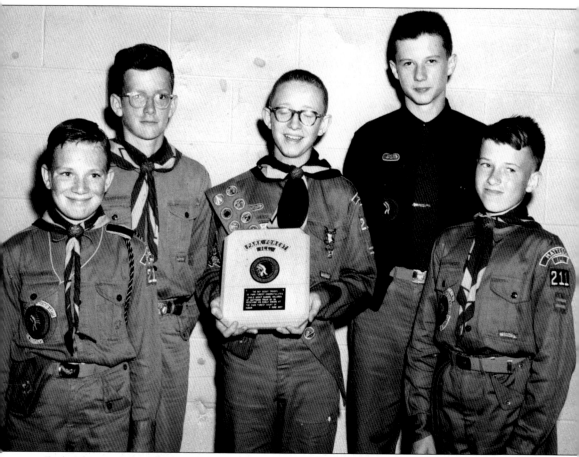

BOY SCOUTS, MID-1950S. This image was taken during the time that the Boy Scouts held meetings in a log cabin that was constructed in 1939. The cabin was located between the American Legion hall and the Illinois Central tracks but was demolished some years ago. These scouts were members of Troop 211. Shown, from left to right, are Bill Owler Jr., William Frost, Dam Coldren, Tom Heenan, and William Welke. The troop was first sponsored by the American Legion.

Six

SCHOOLS

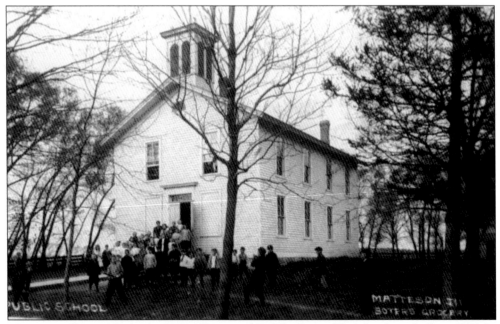

MATTESON PUBLIC SCHOOL, 213TH PLACE, 1910. The first public school was built in 1865 for the sum of $2,500. William Vanderwater from Canada was the first principal. In 1876, a second floor was added. Spelling, writing, reading, grammar, arithmetic, geography, music, history, bookkeeping, and drawing were the subjects taught in the early days of the school. In 1910, 58 boys and 42 girls attended the school.

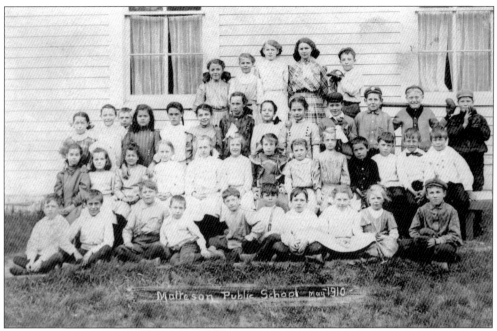

MATTESON PUBLIC SCHOOL, 1910. This photograph of the lower grades was taken next to the old frame building that was built in 1865. Grace Hutchinson and Anna Reynolds were the teachers during this time.

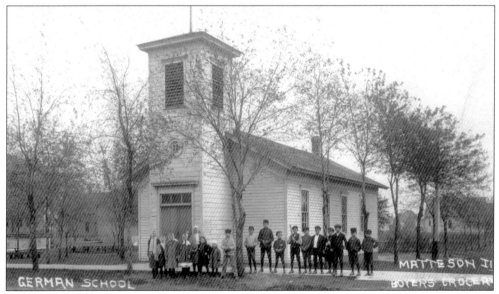

GERMAN SCHOOL, 1915. Built in 1868, this school building was moved from the corner of 216th Place and Maple Street to the corner of 217th and Maple Streets in 1898. "German School" was an early name given to the Lutheran School, reflecting its German heritage.

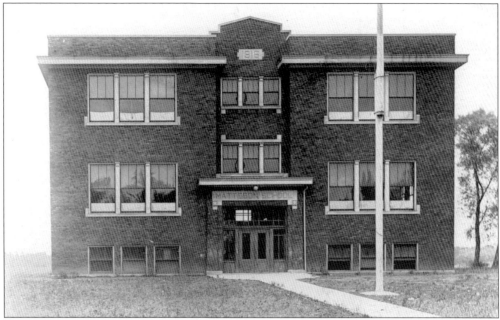

MATTESON PUBLIC SCHOOL. This building was built in 1916 to replace the original school constructed in 1865. In 1966, it became an upper-grade center.

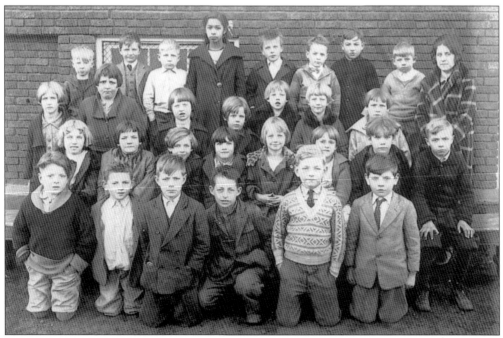

MATTESON PUBLIC SCHOOL, 1926. On the top row to the far right is teacher Stella Cleary, who taught in the system for many years. African American students came from families that worked for the Illinois Central Railroad in town.

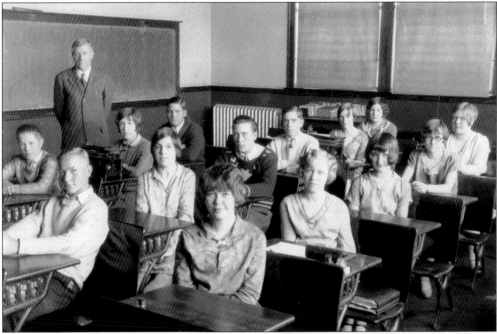

MATTESON PUBLIC SCHOOL, 1928. The upper-grade classes were taught by Fred Lustfeldt, who is standing to the left. Pictured from left to right are (first row) Harriet Claussen, Dorothy Dettmering, Norma Heine, Rosella Shutz, and Marie Holtz; (second row) Wes Grosche, Marie Schoeling, Lawrence Schultz, Paul Becker, Helen Reichert, and ? Anglund; (third row) Fred Templin, Mildred Pieper, and John Umland.

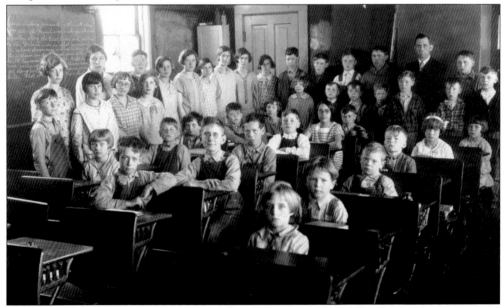

SIEDEN PRAIRIE SCHOOL, DISTRICT 159, EARLY 1930S. Matteson's rural population was served by this one-room schoolhouse constructed in 1869. Students ranging in ages from 7 to 16 were instructed by just one teacher. Many students had only spoken German on the first day of school and were taught to speak English. The teacher, Mr. Hollstein, is pictured on the far right.

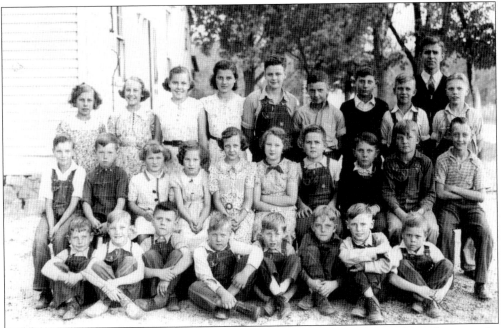

IMMANUEL LUTHERAN SCHOOL, EARLY 1930S. This school served the rural population to the west of the village. It was located on the northwest corner of Sauk Trail and Cicero Avenue. Erwin Klemp, who served as a teacher from 1929 to 1945, can be seen in the upper right.

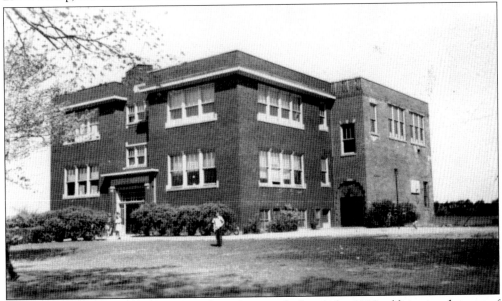

MATTESON PUBLIC SCHOOL, 1928. This photograph shows the 1928 addition to the rear of the building, which included three additional classrooms and a gymnasium. This was done to accommodate the new two-year high school program, which later was expanded to three years. The enrollment never exceeded 40 students. In 1942, the high school program was closed due to low enrollment. Students at this time were given a choice to go to Thornton Township High School or Bloom Township High School. In 1953, Rich East High School was built and Matteson high school students started attending this school.

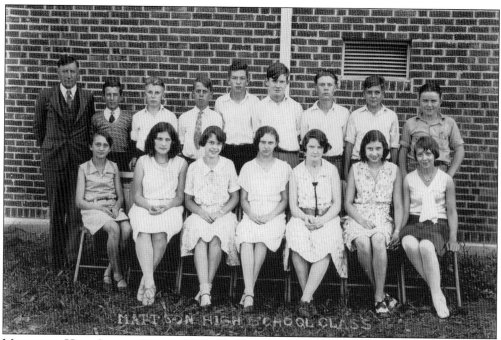

MATTESON HIGH SCHOOL CLASS, 1930. Shown here from left to right are (first row) ? Steinmetz, Helen Reichert, Ellen Jahn, Evelyn Dettmering, Mary Jane Connoly, Louise Allemong, and Ruth Becker; (second row) teacher Fred Lustfeldt, Ed Wollenberg, Bob Musich, unidentified, Leo Whitcomb, Jim Connoly, Norman Brie, Bill Patterson, and Clarence Schutz.

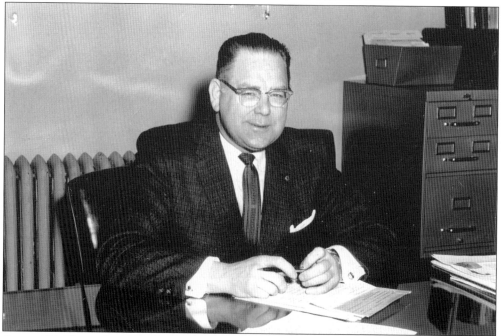

OSCAR W. HUTH. In 1940, Oscar W. Huth became principal of Matteson Public School. He served faithfully until passing away in 1968. The original public school was changed to an upper-grade center in the mid-1960s and was later named after Huth.

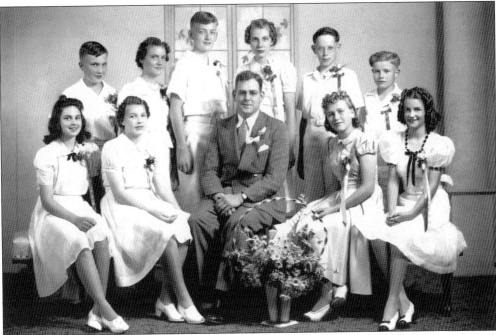

MATTESON EIGHTH-GRADE GRADUATION, 1940. This was the first year that Oscar W. Huth taught in Matteson. Shown are, from left to right, (first row) Dolores Pryor, Jackie Zumbahlen, Huth, Joann Watson, and ? Perkins; (second row) Andrew Macmullen, Shirley Myers, Fred Golden, Elsie Heusman, Russell Harrus, and Robert Hammer.

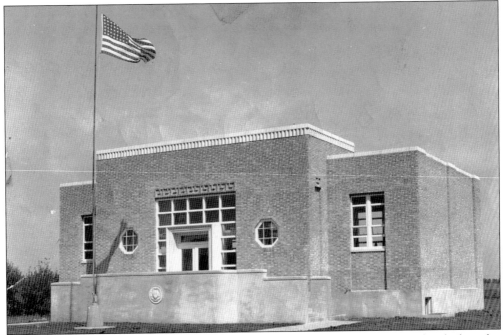

ZION LUTHERAN SCHOOL, 1944. This attractive brick structure was just completed when this photograph was taken. The building stayed in this form until 1960 when the front was altered to blend with the new structure.

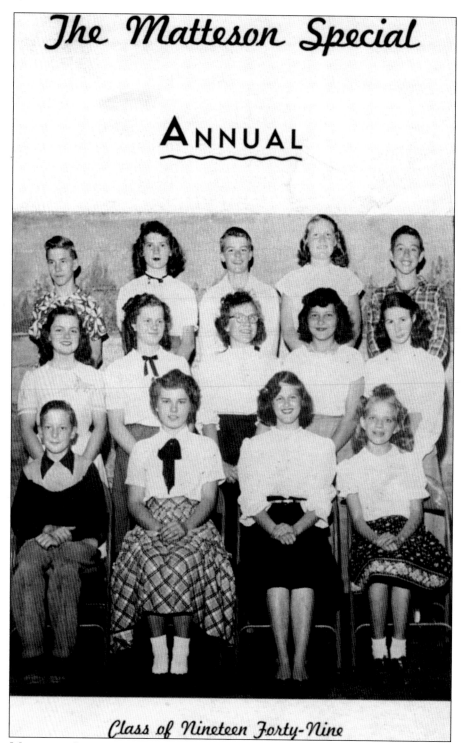

The Matteson Special

ANNUAL

Class of Nineteen Forty-Nine

THE MATTESON SPECIAL, 1949. Borrowing the name of the Illinois Central suburban express train, this publication was the yearbook of Matteson Public School. Each year the cover featured the eighth-grade graduation class.

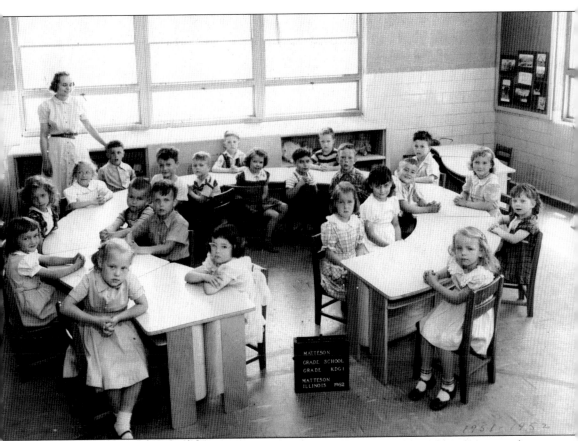

MATTESON PUBLIC SCHOOL, KINDERGARTEN CLASS, 1952. Postwar modernization in the school system was taking place due to the increase in school enrollment, as evidenced by students sitting at new desks. School District 162 was also feeling the effects of the growth of nearby Richton Park and Park Forest. Miss Smith is the teacher standing in the left corner.

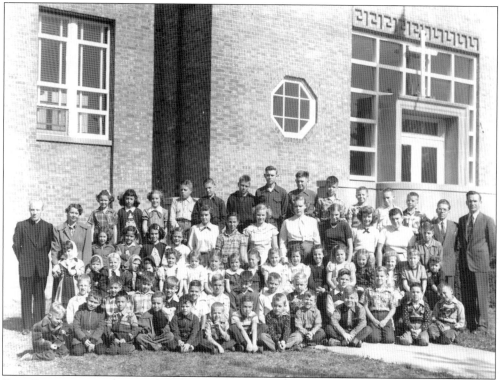

ZION LUTHERAN SCHOOL, 1953. The kindergarten through eighth-grade classes are standing in front of the school that was constructed in 1944. Ernest Wunderlich, principal at Zion from 1952 to 1981, is seen to the far right.

MATTESON PUBLIC SCHOOL ADDITION, 1962. In 1962, this addition was constructed to relieve the overcrowding of the original public school, later to be called the Huth Upper Grade Center. It was a period of great expansion for the school district, with new schools being constructed in neighboring towns rather than making frequent additions to the original building.

Seven

VETERANS

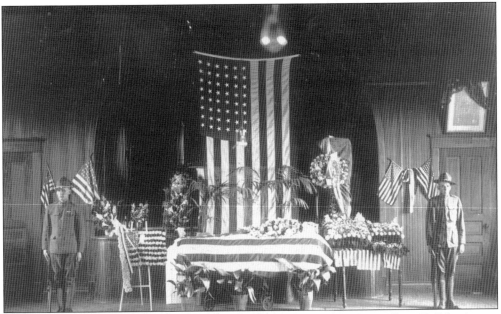

MILITARY FUNERAL. The first military funeral was held in the Matteson Village Hall for August Hedtke during World War I. Fred Schoeneman is the soldier on the right. The American Legion Rehfeldt-Meyer Post 474 was founded in 1931 by Matteson's World War I veterans and was named after two men from the area who were killed during the war. The men and women of Matteson have never hesitated to serve the needs of their country in time of war. Even though the population of the village was small, the accomplishments of its veterans loomed large among the community.

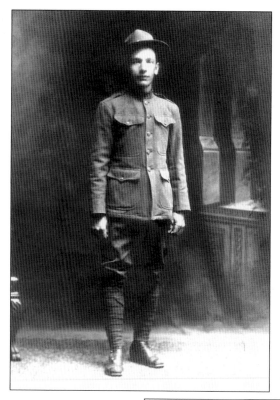

OTTO HOGER. Otto Hoger was on his way to France when the armistice was signed on November 11, 1918.

GEORGE O. ROSS SR. George O. Ross Sr. was an army veteran of World War I and took part in many Memorial Day observances in Matteson. He was born in 1892 and passed away in 1988. He served in a horse-drawn caisson battalion during World War I in France. This photograph was taken at the Memorial Day parade in 1976.

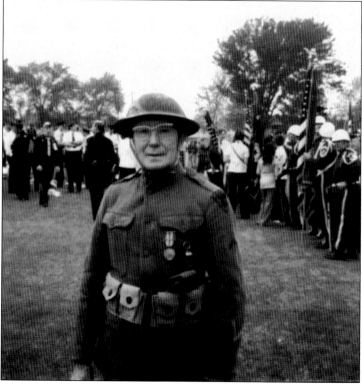

ALVIN NIEMEYER. Alvin Niemeyer went into the army in May 1942 and received a Purple Heart for the campaign in Tunisia during World War II. He also served in Morocco and Sicily and received an honorable medical discharge in January 1945.

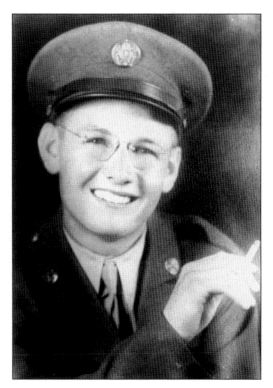

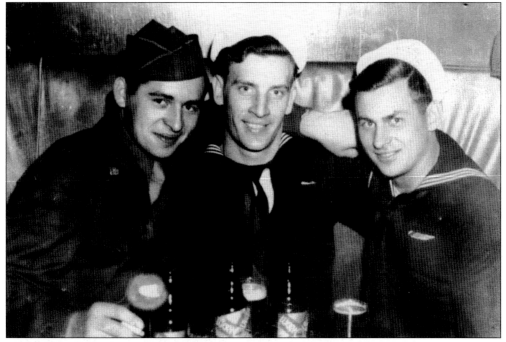

MATTESON AREA SERVICEMEN REUNITE. From left to right are Otto Juergens, U.S. Army; Irwin Hoger, U.S. Navy; and Emil Juergens, Seabees. The men are pictured together at the Pioneer Cafe in San Francisco during World War II for some rest and relaxation.

LAWRENCE ALLEMONG. Village president Frank Allemong's son served as a sergeant during World War II.

CHARLES RUDOLPH "RUDY" ADAMS. Standing in front of the barbershop his father founded, Rudy Adams was a veteran of World War II. He later returned to help his father run the family business.

AUGUST F. DAHLMAN. August F. Dahlman served as an aviation electrician's mate in the navy from 1943 to 1945. He later ran a television repair business in Matteson for many years.

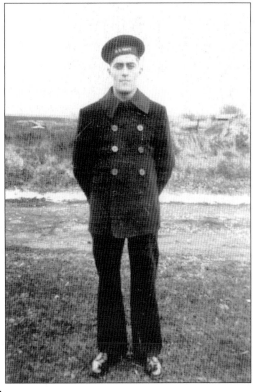

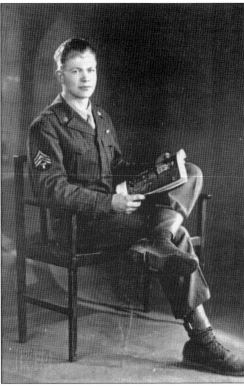

ELMER STEGE. Elmer Stege was a sergeant in the infantry during World War II. He was stationed in Japan and served as a diesel mechanic for heavy equipment in the Engineer Battalion.

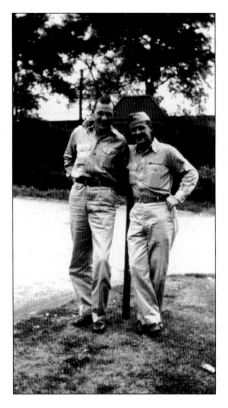

HANK HEINER AND ROY PRAYE. Hank Heiner (left) was in a railroad battalion during World War II in France, and Roy Praye (right) was in the Army Engineers. This photograph was taken at the southwest corner of 216th and Main Streets. In the background is the Illinois Central right-of-way.

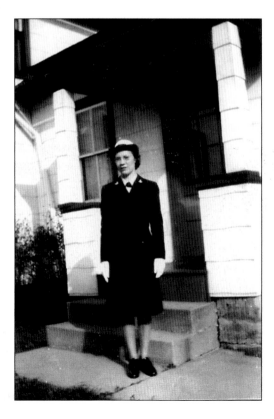

STELLA MAHLER. Stella Mahler served in the WAVES during World War II. Her parents were William and Elizabeth Mahler.

WILLIAM A. JAENICKE. William A. Jaenicke served in the army from 1942 to 1945 in the Combat Engineers. He was part of the D-day invasion and also participated in the Battle of the Bulge conflict in Belgium. This picture shows the Rhine River in the background at Remagen, Germany.

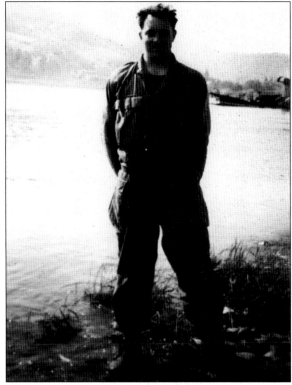

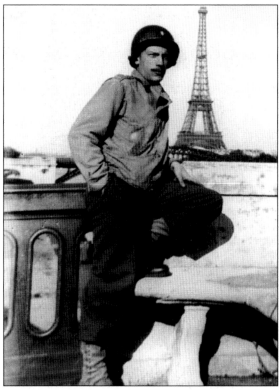

JOHN KELLOGG. John Kellogg was a first lieutenant in Paris when this photograph was taken in September 1944.

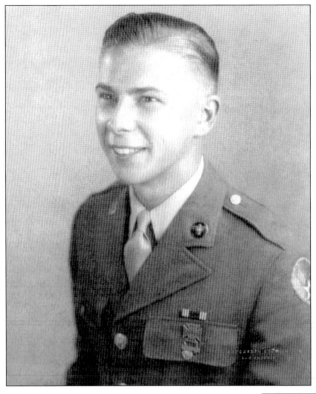

JOHN M. BACKUS. John M. Backus was in the army air force from 1943 to 1946. He served as an airplane mechanic on B-52s and other fighter planes at Wheeler Air Field in Hilo, Hawaii.

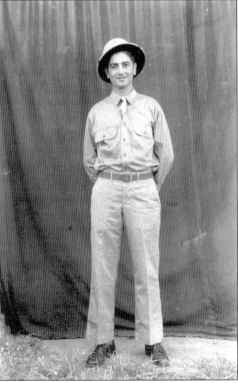

PAT MALONI. Pat Maloni had served in the army and was stationed down in the Panama Canal during World War II. Later on he ran his father's tavern business in Matteson.

EUGENE UMLAND. Eugene Umland served in Korea from 1955 to 1957 in the Heavy Weapons Company of the 7th Infantry Division.

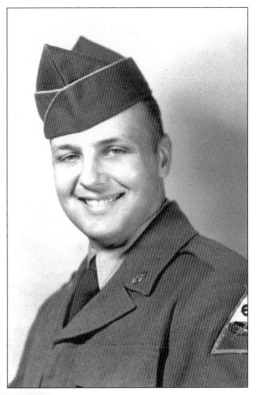

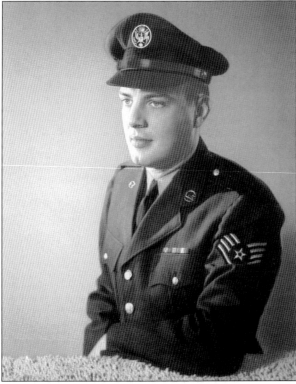

GERALD L. UMLAND. Gerald L. Umland served as a staff sergeant in the air force from 1951 to 1955 in the electrical maintenance area.

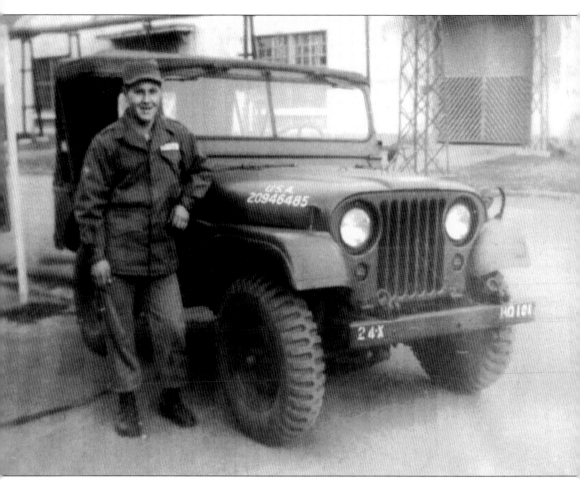

ARVIN STEGE. Arvin Stege served in the army and was stationed in Schimmelpfennig, Sendai, Japan, during the fall of 1952. He later ran a roofing and carpentry business in Matteson.

Eight

RESIDENTIAL LIFE

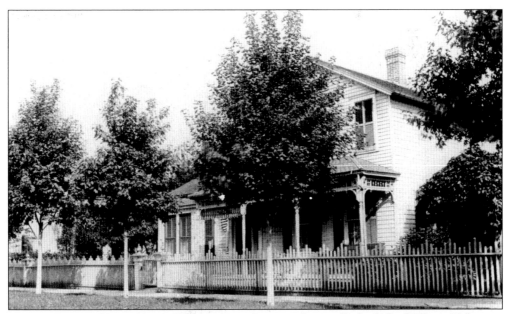

HAHNE FAMILY HOME, 3616 WEST 216TH STREET. Originally built by William Hahne in 1860, this is the oldest residence that still exists in the village. Later on it was operated by the Muff family as a slaughterhouse. Amanda Muff, daughter of William Hahne, lived in this Victorian-style home until her death in 1974.

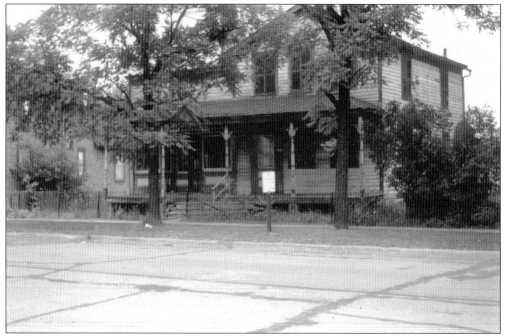

THE GROSS HOUSE, 3624 WEST 216TH STREET. Built in 1875 by Henry Gross, who constructed a harness shop along the west side of his living quarters, the house was later occupied by Gross's daughter Barbara, who lived in the building until 1958 and had many quilting parties here. This photograph shows the house just before remodeling took place in 1962, when it was purchased by attorney Henry Lehmann.

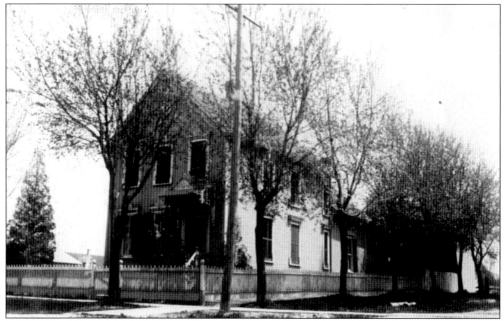

THE NORTMEIER HOUSE, 3735 WEST 216TH STREET. Built in 1894 by Herman Stege for Henry and Sophie Nortmeier, this Victorian-style house is a perfect example of Midwest American architecture around the beginning of the 19th century.

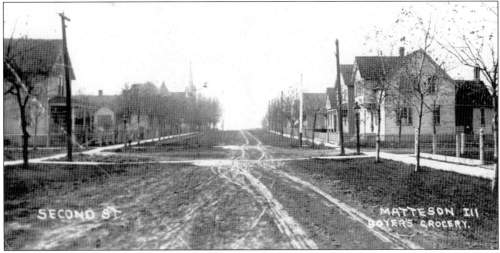

SECOND STREET LOOKING EAST FROM LOCUST STREET. In the early 1900s, Matteson did not have paved streets. It was not until the 1920s that residential streets were paved. Second Street was later called 216th Place when the Chicago street-numbering system was adopted in 1945.

LOOKING WEST FROM 213TH PLACE. New housing was being constructed during the 1920s before the Great Depression of the 1930s put an end to new construction. This photograph was taken facing the south side of the street.

99

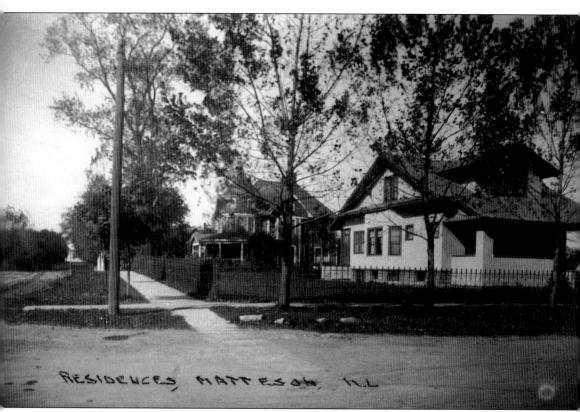

NORTHWEST CORNER OF 213TH PLACE. This scene shows the northwest corner of the same street with Matteson Public School in the far distance. In 1905, the village started constructing cement sidewalks in the community.

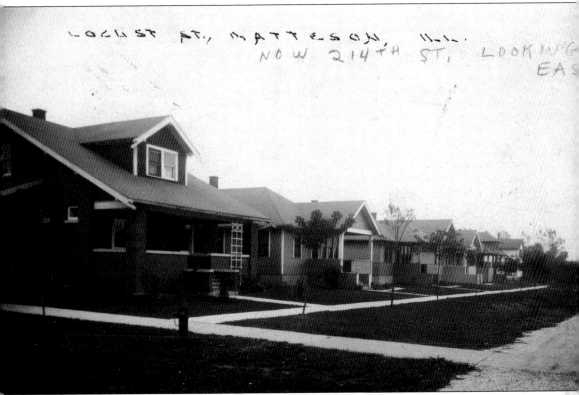

CORNER OF MAPLE AND 214TH STREETS. This subdivision was built in the boom years of the mid-1920s. It was also a time of great optimism with the coming of the new Illinois Central electrification suburban service to Chicago.

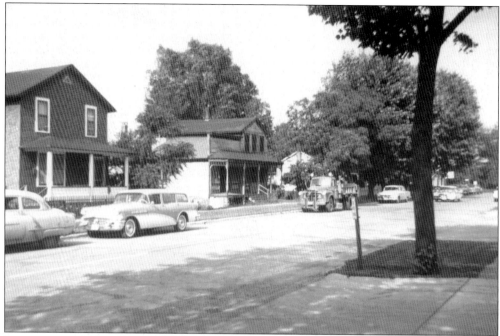

LOCUST AND 216TH STREETS, LOOKING EAST, JULY 1958. Matteson still had a small-town charm to it when this picture was taken from Mahler's Service Station. In the middle of the photograph is the Gross House.

HARRY PIEPENBRINK FARM, 1955. The barn in the background is where the JCPenney store once stood at Lincoln Mall. Shown from left to right are Garrett Woodman, Gene Piepenbrink, and Bernice Umland. Agriculture was once considered an important part of the village economy.

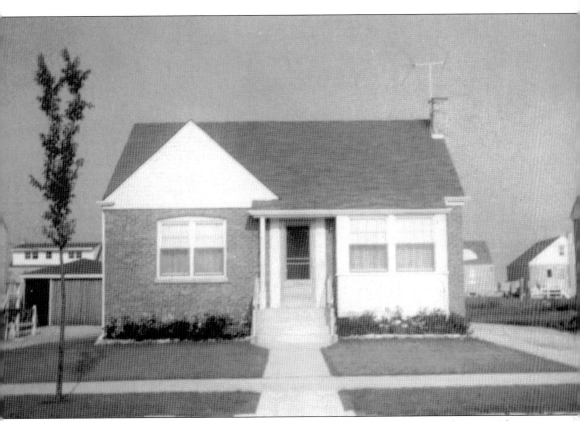

O'CONNER RESIDENTIAL DEVELOPMENT. Starting in 1948, Joseph O'Conner built over 209 homes in the Cape Cod style, ranging in price from $10,000 to $13,000, for returning soldiers. Development started on the south side of the community. This particular house was built in the second phase of development, which took place on the north side of the community in the early 1950s.

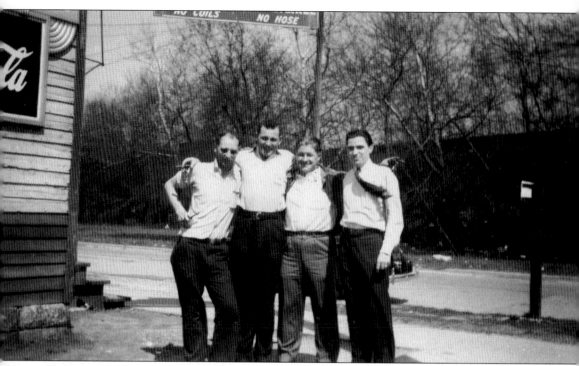

DOWNTOWN MATTESON, 1942. This picture shows the front of Vernon Boyer's tavern (Bunky's) in 1942 at the corner of 216th and Main Streets. Pictured from left to right are Art Schaefer, Hank Heiner, Roy Praye, and Vernon Boyer. From 1937 to 1979, Boyer was the owner of Bunky's Tavern, which is the building to the left in the photograph.

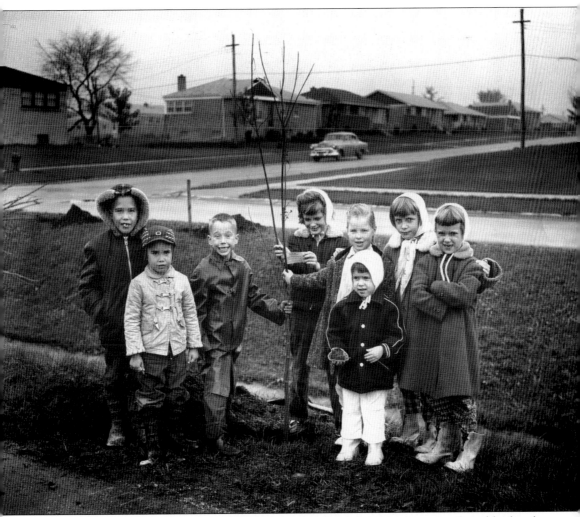

BUTTERFIELD CREEK, 1956. Tree planting was considered an important part of neighborhood beautification in this new residential development. Shown from left to right are Paul Artwohl, Bruce Artwohl, Jim Artwohl, Gail Shore, Kay Ann Schmidt, Jean Stoll, Barbara Stoll, and Debbie Stoll.

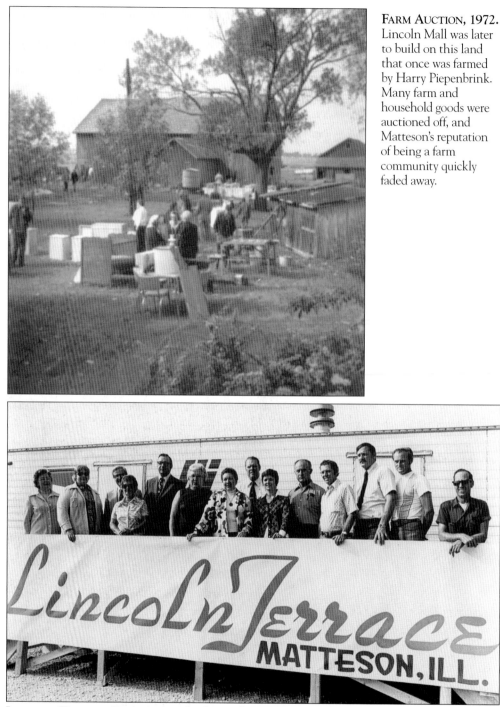

FARM AUCTION, 1972. Lincoln Mall was later to build on this land that once was farmed by Harry Piepenbrink. Many farm and household goods were auctioned off, and Matteson's reputation of being a farm community quickly faded away.

LINCOLN TERRACE DEDICATION. In September 1976, groundbreaking ceremonies took place at this subdivision located west of Governors Highway and 216th Street, with village officials celebrating the event. From left to right are Marcella Melvin, Judy Woodruff, John Gutgsell, Clara Feehery, Joe Feehery (village president), Teddy Rosen, Nancy Felkamp, Wilbur Ellis, Marilyn White, Roy Jung, Frank Denman, Randy Drews, Jack McGrath, and John Schurz.

Nine

TRANSPORTATION

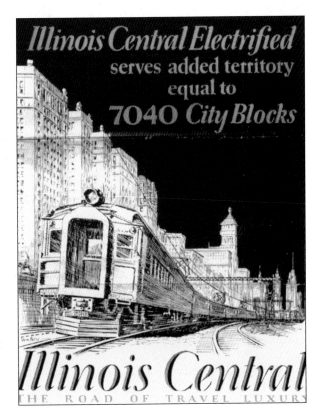

THE COMING OF THE ILLINOIS CENTRAL ELECTRIFICATION, 1926. Matteson was the termination point of the Illinois Central electrification when this advertisement came out. It was a boom not just to this village but to all the south suburbs. To this day, much of the development in the area can be attributed to having frequent train service to Chicago for employment, education, and entertainment.

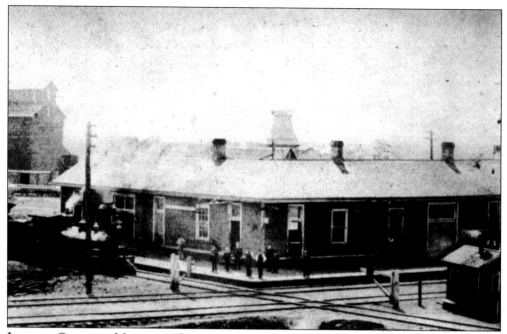

ILLINOIS CENTRAL–MICHIGAN CENTRAL DEPOT, C. 1880S. This was a joint agency depot built in 1863. It also served as a meeting place for the village board. In the background are the windmill and grain elevator that served the local farmers. This depot was demolished at the time of the track elevation in 1922.

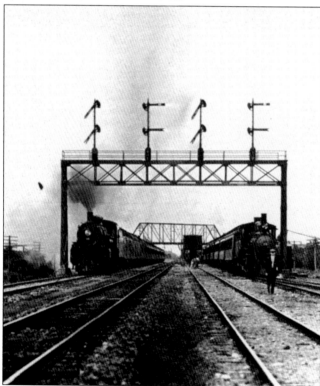

ILLINOIS CENTRAL RAILROAD LOOKING SOUTH, BEFORE ELEVATION, C. 1915. The train on the right shows how Illinois Central suburban trains looked before electrification. In 1912, suburban service was extended to Matteson along with the laying of two additional tracks. Trains backed into the station, which is underneath the interurban bridge to the left. The wooden water tank to the right was used to put water in the tenders of the suburban engines. A water reservoir was located to the east and west of the right-of-way. To the left can be seen a northbound main line express train.

ILLINOIS CENTRAL INTERLOCKING TOWER, c. 1915. The building in the background was an interlocking tower that protected the crossing of the Illinois Central and Michigan Central trains and also controlled the switching of the suburban trains to the depot, which is out of the photograph to the right. This view is looking southeast. The men in the photograph are Illinois Central employees. The picture was taken before the tracks were elevated.

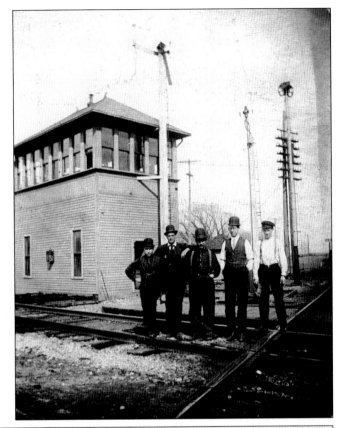

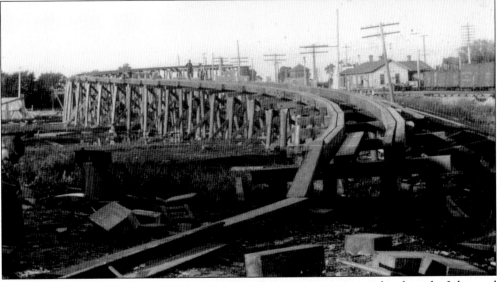

INTERURBAN TRESTLE CONSTRUCTION, 1908. Construction was completed on the Joliet and Southern Traction Company trestle in 1909. Service was between Joliet and Chicago Heights with a one-car train running every two hours during the daytime. In 1914, the company went bankrupt and reorganized as the Joliet and Eastern Traction Company. This scene is looking northeast from Main Street.

CONSTRUCTION OF INTERURBAN TRESTLE, EAST SIDE OF ILLINOIS CENTRAL, 1908. This scene shows the Fisher Company construction workers putting the finishing touches on the trestle looking east toward Front Street. The bridge was later torn down in 1922 when the Illinois Central elevation was constructed.

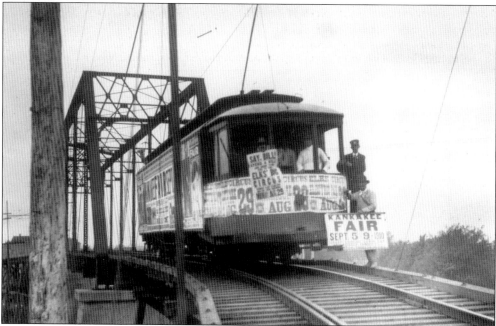

INTERURBAN STREETCAR CROSSING BRIDGE, 1910. This eastbound Joliet and Southern Traction streetcar is seen in September 1910 advertising the Kankakee Fair. The car has just crossed the Illinois Central and is headed for Chicago Heights. The train ran by electric power provided through the overhead wires.

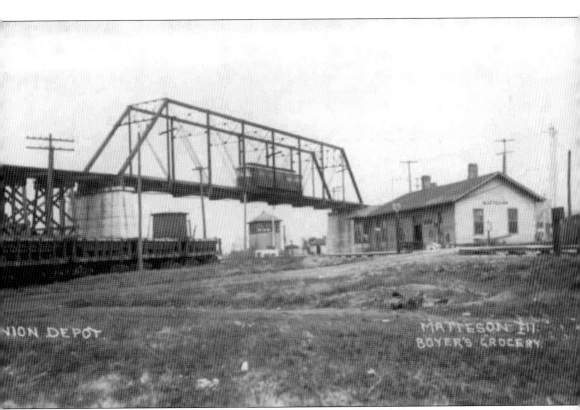

ILLINOIS CENTRAL, LOOKING NORTH, C. 1910. In this view looking north, the interurban streetcar is crossing the Illinois Central tracks. To the right is the Illinois Central–Michigan Central station, which was torn down at the time of the elevation in 1922. North of the bridge to the right is a railroad interlocking tower and to the left is a water tower for the suburban steam engines.

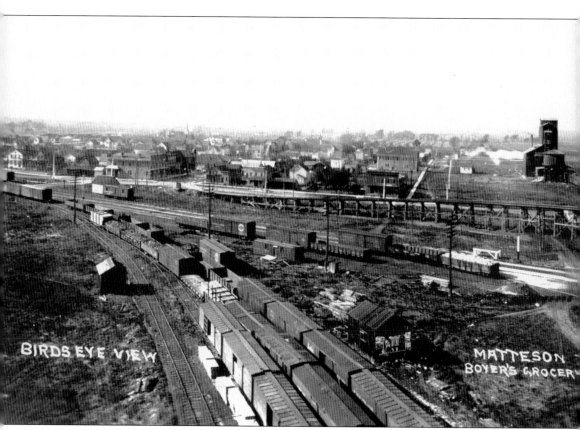

BIRDS EYE VIEW

MATTESON
BOYER'S GROCER

VILLAGE OF MATTESON, 1910. This photograph was taken from the grain elevator that was to the southeast of the Illinois Central–Michigan Central crossing. The view is looking west. In the distance to the right is the Stege Elevator. Across the street is the belfry of the village hall. The business district of Matteson is to the left. The trestle of the interurban line can be seen in the foreground.

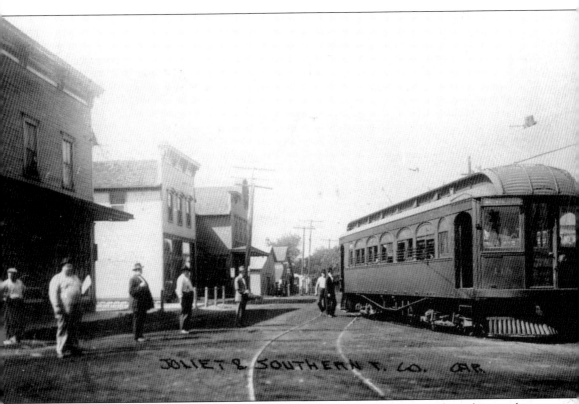

LOOKING WEST DOWN THIRD STREET, C. 1910. This scene shows an eastbound interurban car ready to cross the trestle and head to Chicago Heights. The buildings on the left side are Langworth's Tavern, the F. S. Schroeder Hardware Store, and Dettmering's Tavern. To the right is the German American Bank. The interurban line used 600 volts direct current off a trolley wire for electric power.

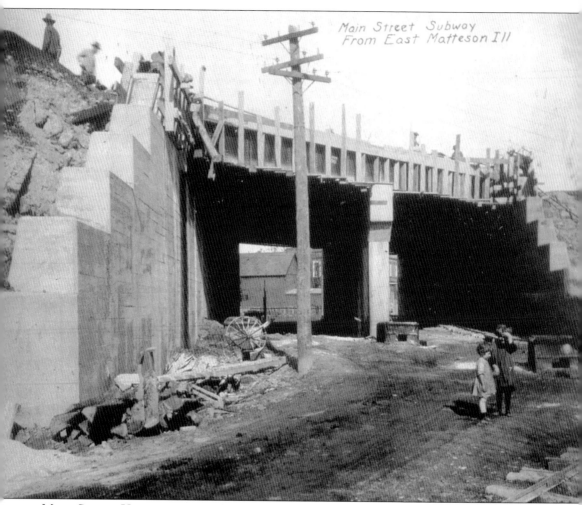

Main Street Subway
From East Matteson Ill

MAIN STREET VIADUCT, 1922. This scene shows the construction of the Main Street viaduct as part of the Illinois Central elevation of tracks. Soil was dug from Monee and brought up to Matteson to elevate the tracks with the fill being laid right on top of the old tracks. The reason for the project was to reduce the grade going south between these two towns. The Illinois Central was also anticipating a surge of northbound coal trains from southern Illinois mines to feed the expanding industrial district of Chicago.

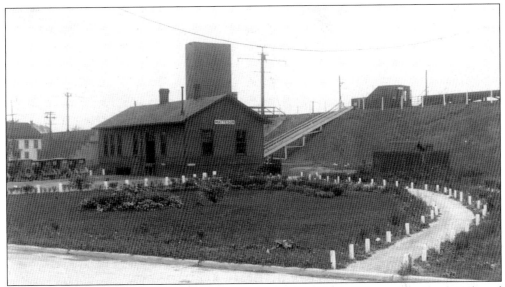

ILLINOIS CENTRAL STATION AFTER ELECTRIFICATION, 1926. When elevation (1922) and electrification (1926) were complete, the railroad built a new freight station for the purpose of handling express and mail. The black structure in the background was a freight elevator that brought shipments to track level. The shipments were then carted across the suburban tracks to the main line tracks. Trains were powered by electric overhead wires carrying 1,500 volts direct current.

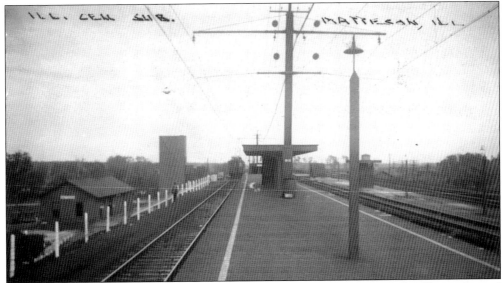

ILLINOIS CENTRAL STATION LOOKING NORTH, 1926. This view shows the Illinois Central station after the electrification project was completed. The new service started on August 7, 1926, with a big parade in Chicago celebrating the event. In addition, the governor of Illinois, Len Small, had piloted the first official electric suburban train from Matteson. To the left can be seen the freight station and elevator along with a southbound commuter train. To the far right is the main line passenger platform that served local passenger trains until September 1954. The freight station was torn down at this time and moved to an office in the platform waiting room.

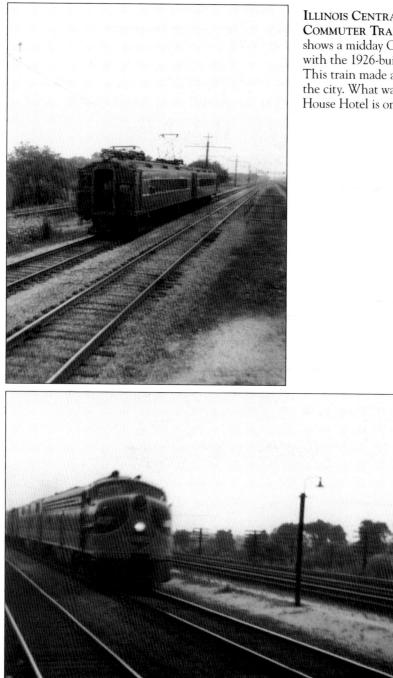

ILLINOIS CENTRAL NORTHBOUND COMMUTER TRAIN, 1956. This view shows a midday Chicago-bound train with the 1926-built commuter cars. This train made all local stops into the city. What was once the Matteson House Hotel is on the left.

ILLINOIS CENTRAL SOUTHBOUND *DAYLIGHT* PASSING THROUGH MATTESON, 1956. The local passenger platform to the right once served passenger trains to southern destinations on the Illinois Central system. In September 1954, the platform was closed and Homewood became the sole passenger stop for main line trains in the southern suburbs. This view shows the St. Louis–bound *Daylight* roaring through town with the Michigan Central freight station barely visible to the right.

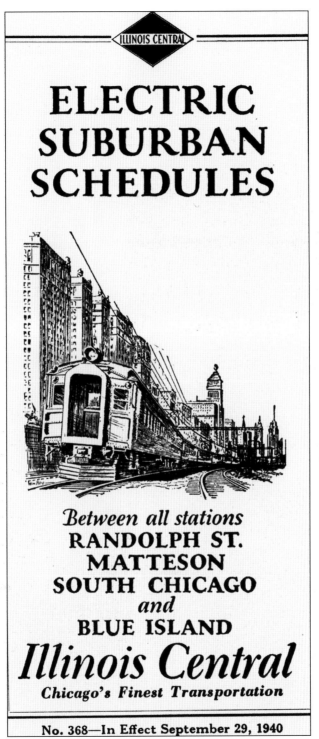

ELECTRIC SUBURBAN SCHEDULES

Between all stations
**RANDOLPH ST.
MATTESON
SOUTH CHICAGO**
and
BLUE ISLAND

Illinois **Central**

Chicago's Finest Transportation

No. 368—In Effect September 29, 1940

ILLINOIS CENTRAL COMMUTER TRAIN SCHEDULE, 1940. For many years, Matteson area residents grew accustomed to these schedules. Express service was offered to the village, and these trains were known as the "Matteson Special."

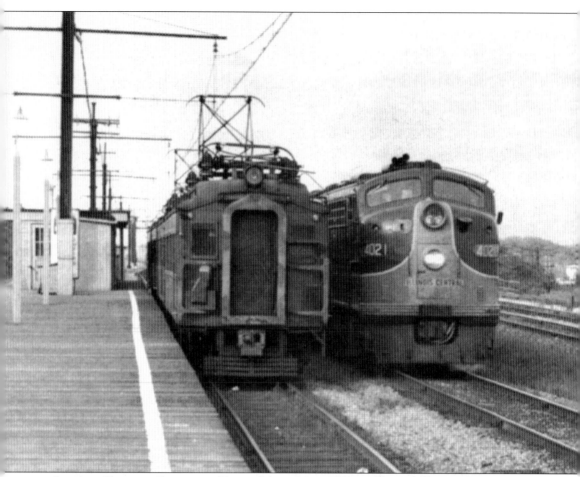

ILLINOIS CENTRAL SUBURBAN TRAIN, MID-1960S. The northbound Illinois Central suburban train has just made its stop at the Matteson platform as a southbound passenger train roars by. New suburban cars for commuters would be coming in 1971.

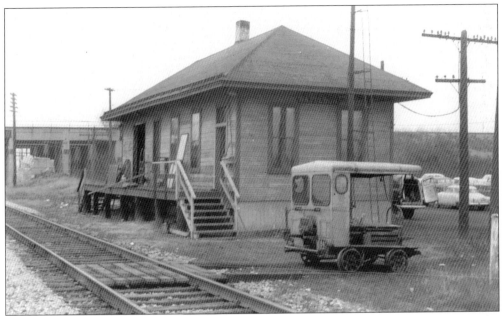

MICHIGAN CENTRAL (NEW YORK CENTRAL) RAILROAD FREIGHT STATION, FALL 1954.
Constructed in 1923 after the Illinois Central tracks were elevated, this station remained in use until 1963. William Walters was the agent here from 1933 to 1961 and also was a longtime resident of the village. Passenger service was offered in the form of two daily trains each way between Joliet and East Gary until being discontinued in April 1915.

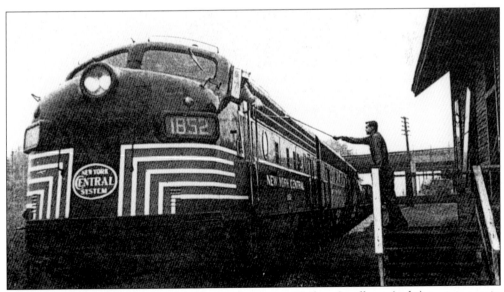

NEW YORK CENTRAL EASTBOUND FREIGHT TRAIN. Nathan Lindhaut (right) is giving train orders to an eastbound train bound for Niles, Michigan, in 1957. In the background, the Illinois Central Front Street viaduct can be seen. This line was known as the Michigan Central Railroad well into the 1930s but later became part of the New York Central system. This line was abandoned in the late 1970s and became part of the Old Plank Trail in 1997. Research shows that this was never built as a plank trail but was constructed as a railroad.

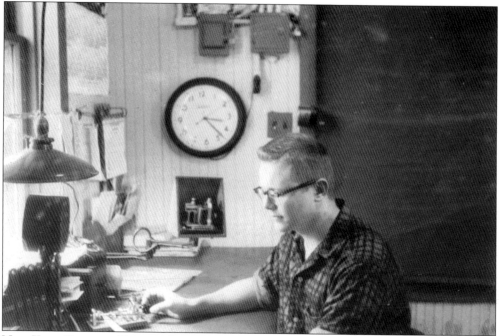

NEW YORK CENTRAL FREIGHT STATION, 1958. Operator-agent Ralph Eisenbrandt is pictured by the telegraph key, which was used to communicate with dispatchers and other railroad personnel. His duties included making out waybills and insuring the safe operations of New York Central trains passing through Matteson. During World War II, many oil trains had traveled this line coming from southwestern states destined for the East Coast.

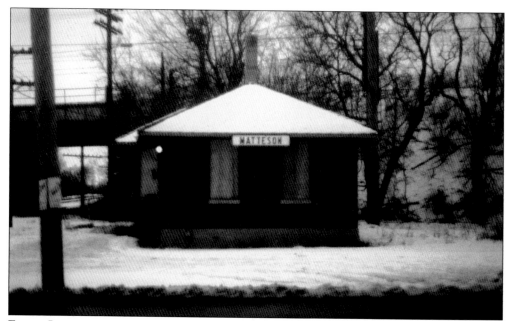

ELGIN, JOLIET AND EASTERN RAILROAD FREIGHT STATION. Built in 1923, this building served the Elgin, Joliet and Eastern until the early 1980s and has since been abandoned. The agent who worked here had performed waybill responsibilities with the nearby Illinois Central freight yard.

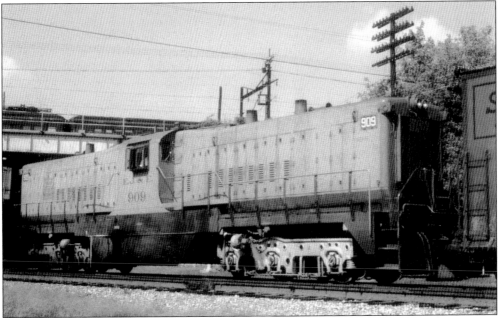

ELGIN, JOLIET AND EASTERN FREIGHT TRAIN, MAIN STREET, SEPTEMBER 1970. The Elgin, Joliet and Eastern started serving Matteson in 1888. Some passenger service was offered to Joliet and Gary, Indiana, until 1908. The railroad forms a beltway around the Chicago area starting at Waukegan and ending at Gary. It once catered to the steel industry that was owned by US Steel at one time.

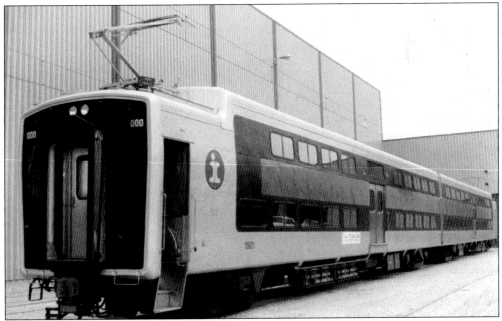

ILLINOIS CENTRAL HIGHLINERS, 1971. New commuter passenger cars started serving Matteson residents in 1971, resulting in improved service and comfort. The cars were purchased by the Chicago South Suburban Mass Transit District (CSSMTD) and leased back to the railroad. One hundred and thirty of these cars were purchased with an additional thirty-six added in 1979.

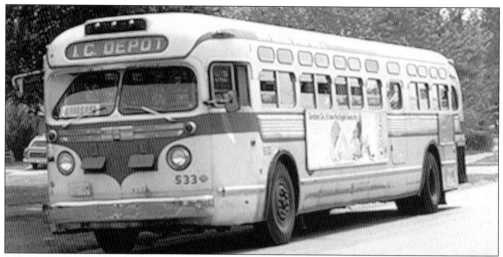

SOUTH SUBURBAN SAFEWAY LINES. Matteson started being served by buses after the interurban streetcar line was discontinued in 1922. Service was once provided to Joliet and Hammond, Indiana, by a predecessor company called the Gold Star Line. When this photograph was taken in the early 1970s, service had been cut back to Frankfort and Chicago Heights.

GOLD STAR LINE — Frankfort, Illinois

JOLIET CHICAGO HEIGHTS HAMMOND

Prevailing Chicago Time				READ DOWN				
	AM	AM	AM	AM	PM	PM	PM	PM
JOLIET	8:00	10:00	12:00	2:00	4:00	6:00
New Lenox	8:20	10:20	12:20	2:20	4:20	6:20
Frankfort	6:50	8:35	10:35	12:35	2:35	4:35	6:35
Lincoln Estates............	...	6:55	8:40	12:40	2:40	4:40	...
Matteson	7:05	8:55	12:55	2:55	4:55	...
CHICAGO HEIGHTS	7:15	9:10	1:10	3:10	5:10	...
Glenwood	7:25	9:20	1:20	3:20	5:20	...
Thornton	7:27	9:23	1:23	3:23	5:23	...
South Holland	7:30	9:30	1:30	3:30	5:30	...
Dolton	7:35	9:35	1:35	3:35	5:35	...
Calumet City	7:45	9:45	1:45	3:45	5:45	...
HAMMOND	7:50	9:50	1:50	3:50	5:50	...

		AM	AM	AM	PM	PM	PM	PM	PM
HAMMOND0	...	8:00	10:00	2:00	4:00	6:00	...
Calumet City	8:05	10:05	2:05	4:05	6:05	...
Dolton	4.7	...	8:15	10:15	2:15	4:15	6:15	...
South Holland	7.2	...	8:20	10:20	2:20	4:20	6:20
Thornton	9.8	...	8:25	10:25	2:25	4:25	6:25	...
Glenwood	11.4	...	8:30	10:30	2:30	4:30	6:30	...
CHICAGO HEIGHTS .	15.3	...	8:40	10:40	2:40	4:40	6:40	...
Matteson	20.3	...	8:50	10:50	2:50	4:50	6:50	...
Lincoln Estates......	26.1		9:10	11:10		3:10	5:10	7:10	

GOLD STAR LINE SCHEDULE, 1956. Residents of the village had very good public transportation service well into the late 1950s. This was before interstate highways and major improvements were made to arterial highways in the area. Buses were not an uncommon way of getting around before the influx of the automobile.

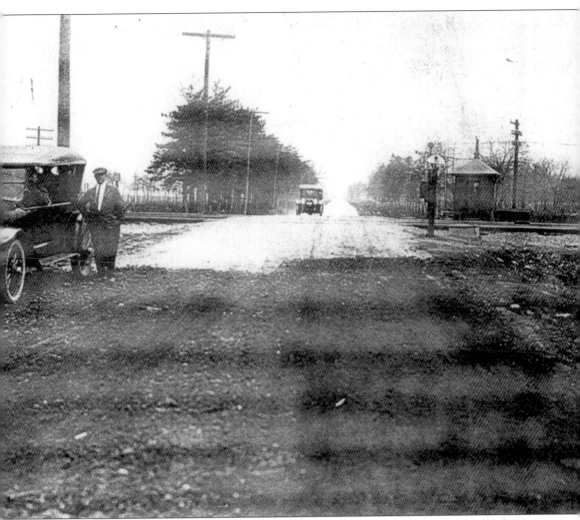

LINCOLN HIGHWAY ILLINOIS CENTRAL CROSSING, C. 1920. This view is looking west down Lincoln Highway from the Illinois Central crossing before the tracks were elevated and the highway was paved. To the right across the tracks is where the entrance once was to Elliott's picnic grounds. The Lincoln Highway was conceived in 1913 as a coast-to-coast highway stretching from New York City to San Francisco.

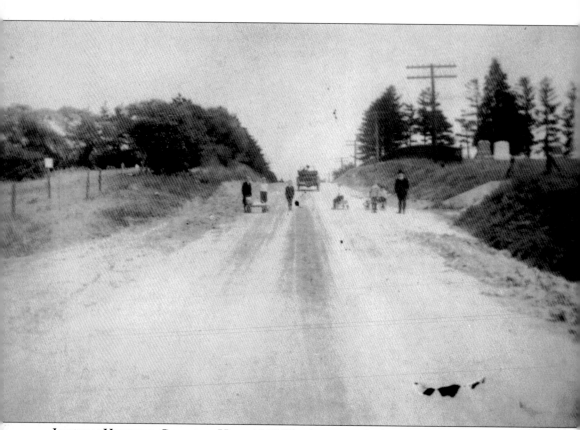

LINCOLN HIGHWAY, CEMETERY HILL, 1917. This location is looking east from where Governors Highway crosses Lincoln Highway. Zion Evangelical Lutheran and Elliott's Cemetery, which was chartered in 1883, are on the right. Many eastbound vehicles had struggled to make it up this hill, which was paved in 1919. In 1926, the federal government adopted a numbering system for the national highway system. Lincoln Highway became known as U.S. Route 30.

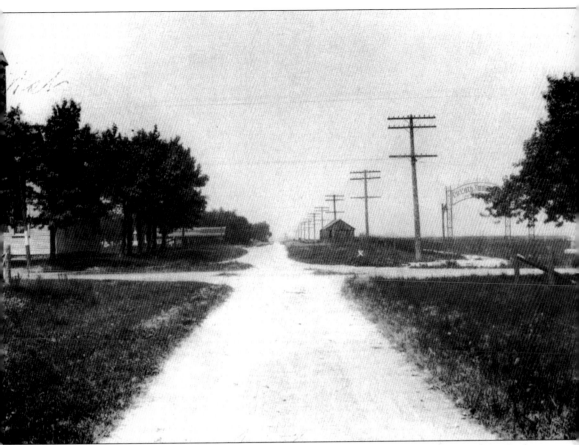

Cicero Avenue and Sauk Trail, 1915. This view is looking north down Cicero where Sauk Trail is seen crossing in the background. To the right is the Immanuel Lutheran Cemetery, which is still at this location. To the left can be seen the old Immanuel Lutheran Church building. This area was once considered part of unincorporated Matteson.

LINCOLN HIGHWAY RECONSTRUCTION, 1984. Lincoln Highway was widened from four lanes to six lanes during this time. Instead of removing the cemeteries on the south side of the highway, several homes were condemned on the Olympia Fields side to the north. This scene is looking west at the corner of Governors Highway and Route 30 (Lincoln Highway). Gerloff's Service Station can be seen to the left. Governors Highway was constructed to the south of this crossing around 1930.

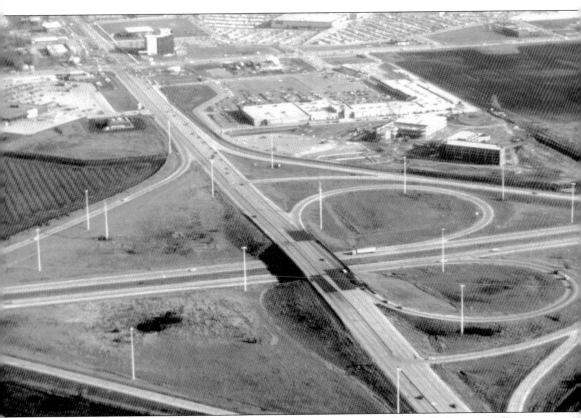

INTERSTATE 57 INTERCHANGE AT LINCOLN HIGHWAY. In November 1968, Interstate 57 was completed through Matteson, linking the community with Chicago in the north and Kankakee in the south. This development stimulated tremendous residential and commercial growth on the west side of the community.